# IMAGES
## *of America*
# STRASBURG

ON THE COVER: Peoples Drug Store served the town for 100 years before closing in 2016. Opened by John M. and J. Ray Miller in 1916, the drugstore was a gathering place with a soda fountain. Popular items on the shelves were perfumes, heart-shaped Valentine boxes of candy and other boxed chocolates, a variety of gifts, over-the-counter medications, and, of course, prescriptions. The main street business closed when competing drugstore chains were built with drive-through windows. (Courtesy of Betty Barr Colson.)

# IMAGES of America
# STRASBURG

Kathy Kehoe and the Strasburg Museum
Foreword by Dennis Hupp

Copyright © 2023 by Kathy Kehoe and the Strasburg Museum
ISBN 978-1-4671-0885-0

Published by Arcadia Publishing
Charleston, South Carolina

Printed in the United States of America

Library of Congress Control Number: 2022941609

For all general information, please contact Arcadia Publishing:
Telephone 843-853-2070
Fax 843-853-0044
E-mail sales@arcadiapublishing.com
For customer service and orders:
Toll-Free 1-888-313-2665

Visit us on the Internet at www.arcadiapublishing.com

*This book is dedicated to Gloria Stickley. She was a writer, a retired school librarian, president and board member of the Strasburg Museum, and a true historian, dedicated to collecting, preserving, and sharing our local history. In our first meeting about this book, she said to me, "I'm older than you and I may not be here when the book is finished." Gloria passed away in September 2021, but I believe she was by my side still mentoring and guiding me. Many times, stuck on the wording of a caption and wishing she were here, an idea would come to mind, I think, because her spirit was whispering in my ear.*

# Contents

Foreword 6

Acknowledgments 7

Introduction 8

1. Downtown 11
2. Family Business 35
3. School Days 75
4. The Neighborhood 109

# Foreword

The Shenandoah Valley of Virginia lies between two mountain ranges, the Blue Ridge on the east and the Alleghenies on the west. For a distance of 50 miles, a third range, the Massanutten, runs through the middle of the valley, and at the foot of the north end of that range lies the town of Strasburg. Founded close to the North Fork of the Shenandoah River primarily by German settlers in the 1700s as Funk's Mill and later Staufferstadt, it was given its current name by an act of the Virginia General Assembly in 1761, a name that hearkens back to the region from whence some of the settlers emigrated, the namesake of the city of Strasbourg in the European region of Alsace-Lorraine. Apparently, the founders found the beautiful, lush Shenandoah Valley to be reminiscent of the old country from which they hailed.

During its long history, Strasburg has seen good times and bad times, prosperous times and not so prosperous times, times of peace and times of war, the latter brought to the very doorsteps of its citizens. Through it all, our people have persevered and pulled together. We are a community in the true meaning of that word. We know each other and care about one another. We bleed purple, the color of our scholastic teams. Churches are sprinkled throughout the town. People come together in a number of organizations that are a testament to our civic pride. I am honored to be the president of one of them, the Strasburg Museum, where we proudly display our history and our culture through donated artifacts reflecting the full scope of our existence as a community.

I am a native of this town. My great-great-great-great-great-grandfather, Peter Stover, founded it. I am ever grateful to Kathy Kehoe, who has become our premier storyteller and folk historian. Her tireless efforts to preserve and to share our story are so very much appreciated by our entire community, and we eagerly await each newsletter from the Strasburg Heritage Association, where her articles appear. We welcome the publication of this book and commend it to you all.

—Dennis Hupp

# ACKNOWLEDGMENTS

Of all the people to acknowledge for helping me to accomplish this book, the most important is my husband of 48 years, Mike Kehoe, for his history-saturated brain, an ever-present sense of humor, and his knack of pulling me out of writer's block by saying just the right thing to send me back to my laptop in a fury. He always knows which of our collection of local history books will have the information I need. I am always grateful for our daughter Bridget, who is my biggest fan, proofreader, and cheerleader. A maybe bigger fan is my cat, Cattahoochee, who is always by my side and ready to listen. Adopted by my daughter Katy from a shelter near the Chattahoochee River, "Hoochee" came to live with us when Katy passed away. Barbara Adamson, my friend, fellow Strasburg Heritage Association board member, and president of the Shenandoah County Historical Society, is always there to proof, review, and advise.

My inspiration began with our local historians and authors, Virginia Cadden, C. Douglas Cooley, and, most recently, Gloria Stickley, to whom this book is dedicated.

Most of these vintage photographs came from the Strasburg Museum collection of C. Douglas Cooley; the rest were brought to me to scan by local people who were the caretakers of their family scrapbooks or collection of snapshots. These pictures had been lovingly saved, sometimes in shoeboxes or little envelopes from the company that developed the film, with the negatives tucked in behind. Laura Ellen Beeler Wade shared photographs saved by her mother, who taught second grade at Strasburg Elementary and who saved photographs of the Strasburg May Day parades. Ginger Sager Glading and Donna Campbell also shared parade photographs from family collections. Glenna Loving shared photographs she took of the elementary school fire in 1968, and Sheryl Pifer shared the pictures her mother, Shirley Pangle, took that day. George Hoffman gave the newspaper clipping his mother had cut out of the *Northern Virginia Daily* published the day after the fire, which gave extra information for the captions. George Hoffman also contributed photographs of his grandfather working at the limestone quarry. Betty Barr Colson shared her collection of photographs of Peoples Drug Store, where her father was a pharmacist, and Park Hottel shared his variety of Strasburg photographs. Marquetta Mitchell, historian and alumna of the segregated Sunset Hill School, provided school photographs. This book would not be possible without these and many others who shared their family collections. Information was gathered from the Strasburg Heritage Association, Strasburg Museum files, and local books about Strasburg. A special thank you to Loretta "Tillie" Rutz Stickles Campbell, who, at 101, could always be depended upon to answer a question from her long memory.

# INTRODUCTION

Much has been written about Strasburg in the last two and a half centuries since the town was founded in 1761. But it has only been in the last century that the story can be told in photographs. Through the photographs Strasburg families have saved and shared, each image in this book tells its own story. As each page is turned, another tale is told. You will find yourself on King Street watching the annual May Day parade, or marveling at the view of the old storefronts where townspeople used to shop. You can study the restaurants and drugstore soda fountains where people gathered. You will watch men in bib overalls working, quarrying the limestone rock to make a living to support their families. You will want a hamburger and a coke at Jimmy the Greek's restaurant or to have Sunday dinner at the Virginia Restaurant on the corner. You will wish you could walk into the hardware store, just to get a whiff of the unique scent only old hardware stores have—that combination of oiled floorboards and bins of nails. You can almost hear the conversations of the men sitting around at the feed store or hear the ding-ding as your car rolls over the hose at the service station. You might feel the anxiety of those gathered around watching the volunteer firemen the day the elementary school caught fire. Very likely, you will want to see more pictures of that well-loved landmark, Massanutten Mountain, and hear more stories about the locally famous Signal Knob.

For several generations of Strasburg residents, before the invention of modern radar, a beacon light warned airplanes the mountain was there. But what people remember about that beacon is the hypnotic flash of the light through the night. They watched it flash from their porches, from their bedroom windows, and sometimes from their car driving down the highway. Their mountain lighthouse showed the way home.

German immigrants left Pennsylvania in the 1730s to homestead in the Shenandoah Valley and settle in an area they would later call Strasburg. Through the years, the streets were paved, the horse-drawn wagons were replaced with cars, and new banks and a new post office sprang up on the main street. The Strand Theater opened on King Street, where talent shows and school plays were held and silent movies were shown. Schools and churches were built and expanded. A town office, a fire department, and a town council were formed. Civil War veterans marched down King Street on Memorial Day. During that Civil War, the churches were used as hospitals, and homes were turned into army headquarters. Sons were drafted and sent overseas in two world wars. When the Great Depression hit Strasburg in the 1930s, the *Northern Virginia Daily* set up a trading system to keep the economy going. The newspaper printed scrip and used it to pay its staff, who in turn would use it to buy groceries. This bartering program paid for subscriptions, which kept the newspaper running. Other businesses participated. The Virginia Restaurant accepted the scrip as payment, then used it to pay its employees and to buy food for the restaurant. People grew their own backyard Victory gardens during World War II and used their ration cards, everybody doing their part to send food to our soldiers fighting overseas. Together, the community strived during the Second World War. People participated in the Civil Air Patrol and kept watch for enemy

planes on a civilian lookout tower. In the 1960s, teenage boys climbed part way up Massanutten Mountain and painted a rock ledge bright orange. The next morning, when the sun hit that painted rock, looking every bit a distress signal, people looked up and noticed something was different. The Civil Air Patrol hiked up the mountain to investigate. When they found a painted rock and discarded cans of paint, they were relieved it was not a downed plane or a UFO. But there are no secrets in a small town. By the time they hiked back to town, the boys had bragged so much the whole town knew who the pranksters were. With paint stains still on their hands, the boys were made to carry cans of a neutral gray back up the mountain, redo their paint job, and carry all the paint cans back. How I wish we had a photograph of that! By the turn of the 20th century, professional photographers were hired to take pictures for the schools and for family portraits. By the 1940s, cameras began to be more affordable, and people began to take pictures of parades and family events. Because of the expense, usually only one picture of one scene was snapped. If the photograph was blurry or did not turn out, you would not know until you got the pictures back from the company that developed the film, after you had paid for it. Nobody wanted to waste film, so they were careful not to take too many pictures. Polaroid cameras were in use by the 1960s and gained popularity, but that film was expensive, too, and after you took the shot, you had to wait several minutes before the picture cleared enough to see if it was a good photograph. So, in other words, snapshots, taken by people who were not professional photographers, were limited. But when those pictures were taken and developed, saved, and, most importantly, found later by family members, and especially if the people and places were identified, then they became valuable treasures. Eventually, a collection of vintage photographs was compiled by C. Douglas Cooley and stored at the Strasburg Museum. This collection would be the main source of photographs for this book along with borrowed images from scrapbooks and photo albums people in the community shared. The end result is a somewhat random collection of interesting photographs that fit together like a jigsaw puzzle to tell the story of the town.

Parades are still part of our small town heritage. You will find it interesting to see how King Street looked in the old days when you view the parade pictures. If you are at the town park watching a soccer game or swimming in the town pool, look up at Signal Knob and be glad you know the significance of that natural landmark. I have scanned over 150 photographs for this book in the special format required. I wish I could continue to collect and scan hundreds more. I know they are out there, in photo albums, scrapbooks, shoeboxes, or maybe a paper sack. But if I could scan all those amazing pictures, this book would never be ready to publish.

These old photographs only show a fraction of our history and only give a glimpse of what our town is, what it has been, and what it will become. But I think Strasburg will always be a place people will be proud to call home, where they can walk downtown for an ice cream cone, listen to live music on the town square, and visit with their friends and neighbors. Small towns have no secrets, but they do have a general sense of understanding for their neighbors.

These are the stories I want to preserve and the memories I want to share. In the summer, the town sponsors live music on the town square. It's called Front Porch Fridays. This is a new event, but it is carrying on the ageless tradition of porch sitting. This is my hometown, and I want to share it with you now in these vintage photographs that townspeople have so generously shared with me.

# One

# DOWNTOWN

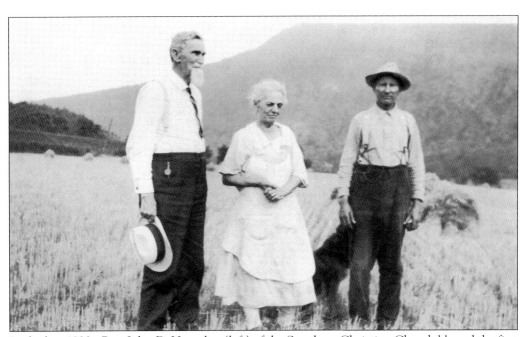

In the late 1920s, Rev. John D. Hamaker (left) of the Strasburg Christian Church blessed the first harvest on the George W. Beeler farm near the Shenandoah River. Standing with him against the backdrop of Massanutten Mountain are George Beeler and Laura Stickley Beeler. (Courtesy of Laura Ellen Beeler Wade.)

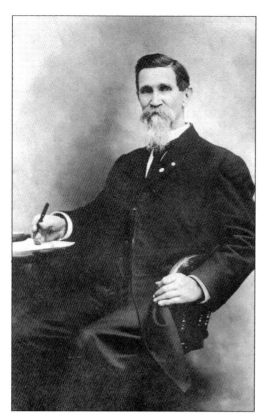

This is a portrait of Rev. John D. Hamaker, the minister of the Strasburg Christian Church for over 35 years. Born in 1847, he was a Confederate veteran who was just a teenager when he became a Civil War soldier. According to the May 10, 1917, edition of the *Strasburg News*, he was one of the first directors of Strasburg's first bank, the Massanutten Bank, and was described as "a highly respected and very capable counselor." Reverend Hamaker died in 1931 at the age of 84. (Courtesy of Laura Ellen Beeler Wade.)

Reverend Hamaker stands at the foot of Signal Knob with bales of wheat to perform a religious, ceremonial blessing of the first harvest. Massanutten Mountain can be seen in the background of this photograph, taken in the late 1920s. (Courtesy of Laura Ellen Beeler Wade.)

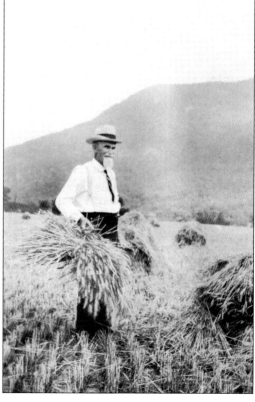

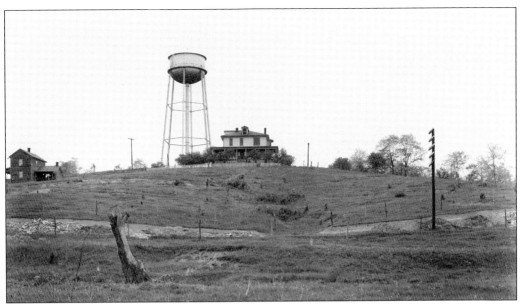

Pictured here is the new town water tower erected on Fort Hill in 1930, before development changed the landscape. Fort Hill is also known as Banks Fort, named after Union general N.P. Banks, who built the fort in 1862 during the Civil War. (Courtesy of Shenandoah County Historical Society.)

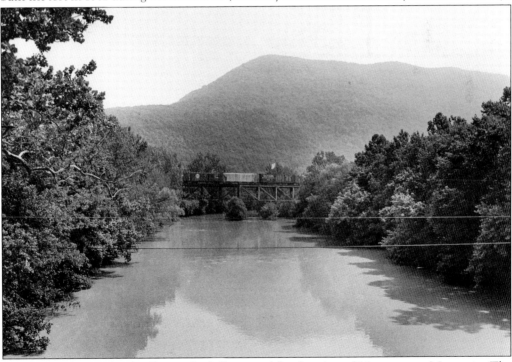

Strasburg is known for the Shenandoah River and for the view of Massanutten Mountain. The mountain peak is called Signal Knob because it was often used as a signal station during the Civil War. Later, a 90-foot tower shone a beacon light to warn airplanes in the night sky. The circling beacon light flashed for years over the town long after radar was invented. (Courtesy of Park Hottel.)

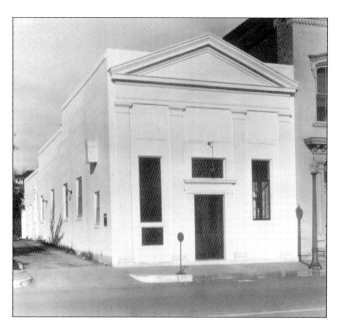

This building was used as the original Massanutten Bank until a new structure was erected across the street in 1953. It adjoined Lloyds Department Store on the right and was next to the new US Post Office on the left. Massanutten Bank was established in 1890, the first bank in the town, and was promoted and organized by prominent citizens R.W. Crawford, E.D. Newman, M.L. Walton, Edward Zea, and J.W. Eberly. The *Strasburg News* reported in 1917 that before the bank was opened, there was no place in town to cash a check or to borrow money. (Courtesy of Strasburg Museum, Doug Cooley Collection.)

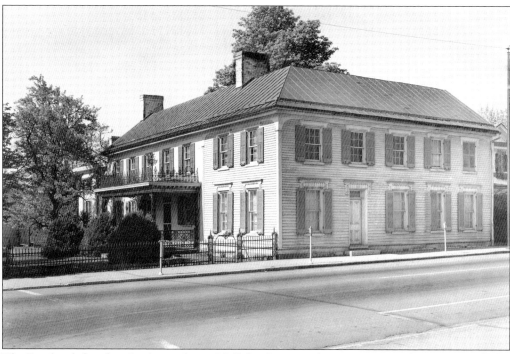

The Zea family lived in this house facing Holliday Street at the intersection of King and Holliday Streets. Originally a stockade, this location was a safe refuge during the French and Indian War of 1754. Later, when the town of Strasburg was established in 1761, this site was the town square, where the town well was located. When the Zea house was torn down in 1952, a new Massanutten Bank was built on the site. Edward Zea was a prominent merchant and the first president of the Massanutten Bank. (Courtesy of Park Hottel.)

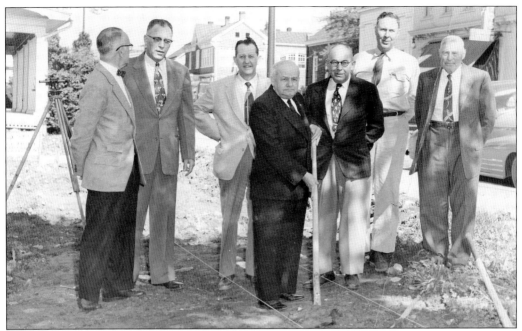

Town officials and bank executives attended the ground-breaking ceremony for the new Massanutten Bank in 1952. Pictured are, from left to right, unidentified, Franklin Borden, Dr. James Marshall Winkfield, Frank Stover (holding shovel), Charlie Platt (owner and operator of the Strasburg Textile Mill), and two unidentified men. (Courtesy of Park Hottel.)

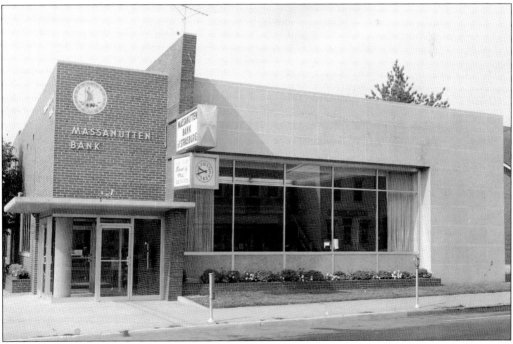

This is a photograph of the new Massanutten Bank. The modern revolving clock on the bank showed the temperature and the time. There were several bank mergers and name changes, but the building currently stands empty. (Courtesy of Park Hottel.)

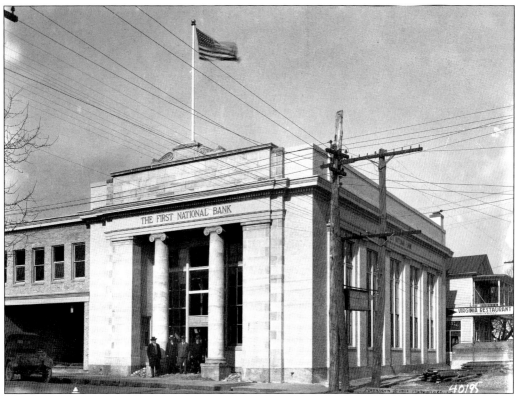

The First National Bank is pictured in the final stages of construction in 1928. The bank first opened in 1907 as Peoples National Bank, changing its name when it moved to the new office building. The name remained First National Bank of Strasburg until 1994, when the bank converted from a national bank to a state bank and adopted its new name, First Bank. The bank is remembered by several generations of children, as each holiday season elementary school students were invited to see Santa Claus at the bank and receive a stocking with a candy cane and an orange. Visible around the corner is the first location of the Virginia Restaurant before it moved to the opposite corner of Holliday and King Streets. (Courtesy of Strasburg Museum, Doug Cooley Collection.)

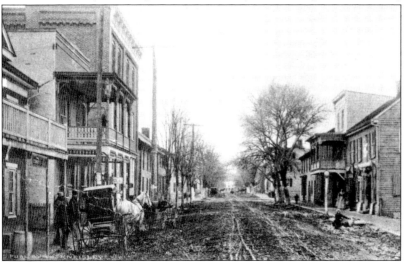

Shown is downtown King Street in the 1920s. Note the horse-drawn buggy parked on the dirt street, which was not paved until the early 1930s. (Courtesy of Betty Barr Colson.)

A view of King Street in 1936 as the new US Post Office was being built shows the sidewalk as it appears today. Also visible is the original Massanutten Bank. (Courtesy of Shenandoah County Historical Society.)

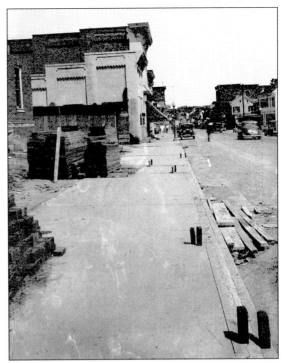

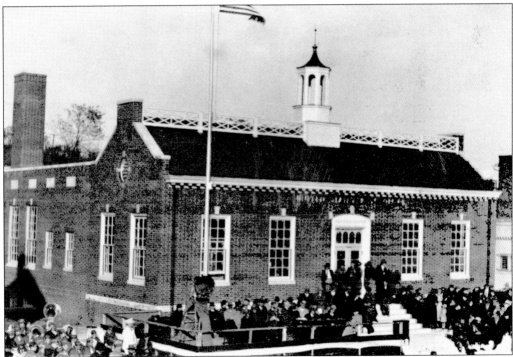

Townspeople and post office officials gathered at the entrance to the new post office in 1936. A large mural by artist Sarah Blakeslee was commissioned by the Works Progress Administration. The painting of apple harvesting covers a wall in the lobby. (Courtesy of Strasburg Museum, Doug Cooley Collection.)

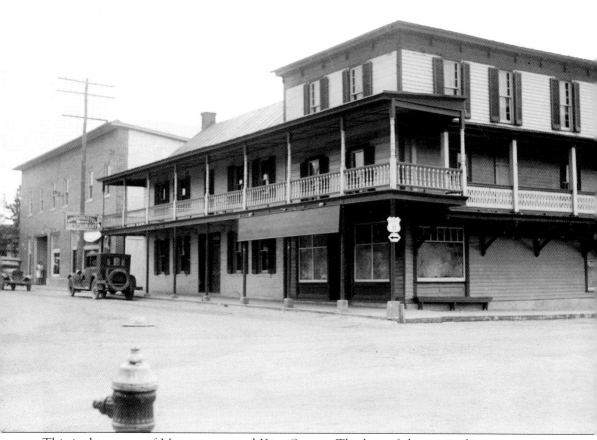

This is the corner of Massanutten and King Streets. The logs of the original structure were eventually exposed, as is seen today. For some 40 years, this corner was the site of a restaurant, including Sylvia's Restaurant, which opened in the 1960s and closed in 1980. It was also the site of the first ethnic restaurant in town, Cristina's Mexican Restaurant. It is now the Strasburg Flea Market. (Courtesy of Shenandoah County Historical Society.)

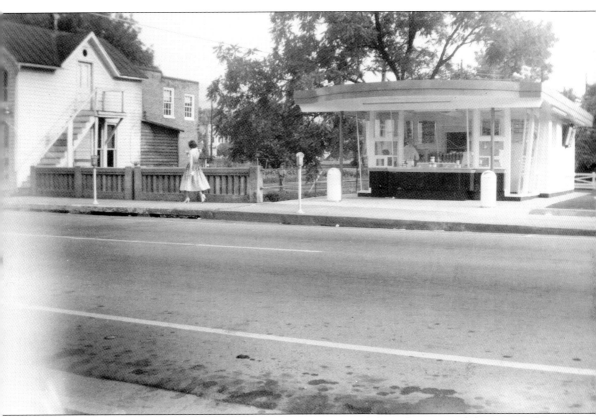

The Tastee Freez was Strasburg's first fast food restaurant and the only one until the 1990s, when Route 11 North was commercialized. Families would stand at the window to order and then sit in their cars on the main street or sit outside on picnic tables next to the Town Run. Summer walks downtown usually led to eating an ice cream cone on the way home. Later, the Tastee Freez added seating and was a popular after-school hangout, where kids could play the jukebox and enjoy hamburgers, French fries, and soft drinks. (Courtesy of George Hoffman.)

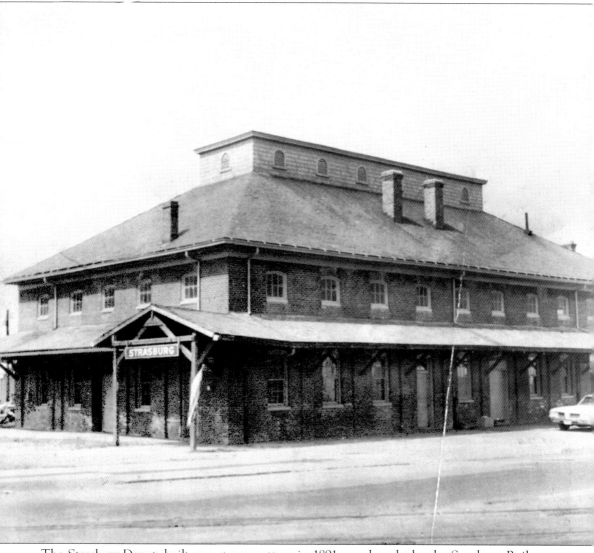

The Strasburg Depot, built as a steam pottery in 1891, was bought by the Southern Railway Company in 1913 to use as a passenger and freight depot. The Strasburg Museum opened here in the 1970s and continues to operate today, displaying local history. (Courtesy of Strasburg Museum, Doug Cooley Collection.)

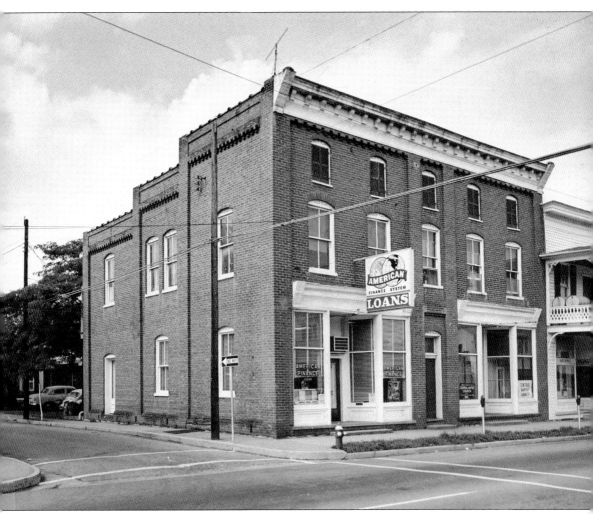

The Kaplan Building, destroyed by fire in 1998, was occupied first by Keister Pottery in 1809, A. & H. Keister Mercantile until 1876, and Eberly Pottery from 1880 until 1900. From 1912 to 1922, E.E. Keister used the building for the offices of a weekly newspaper, the *Strasburg News*, while the Kaplan General Store operated in the building from the 1920s until the 1960s. (Courtesy of Park Hottel.)

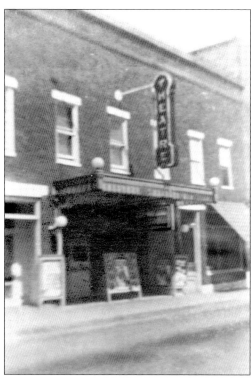

The Strand Theater was the first motion picture house in town. Built in 1918, it was used for silent movies, school plays, and traveling vaudeville shows and continued to show major films until it closed in 1955. Today, it is home to the Box Office Brewery, where some of the Strand history is displayed, including framed movie posters found in the building and murals that have been preserved on the walls. (Courtesy of Strasburg Museum, Doug Cooley Collection.)

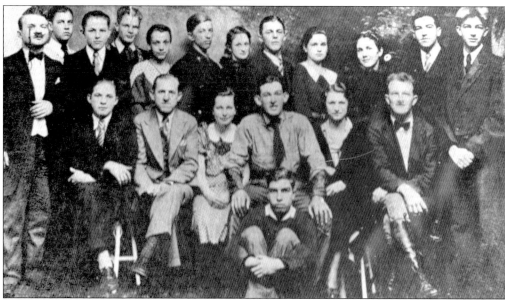

This 1930 photograph shows the cast of *Everybody's Hotel*, a comedy written by Charles Crabill. The play was performed by the Mask and Wig Club at the Strand Theater in Strasburg. Pictured are, from left to right, (first row) Rev. Charles Glaize (on floor); (second row) George Burke, Rev. Fred Wyand, Estelle Johnson, John Finch, Doris Seaton, and Sim Fisher; (third row) Charles Crabill, Carl Brill, John Wake, Charles Cooley, Betty Borden, James Ellis, Helen Little, Machir Ellis, Polly Hoffman, Evelyn Frazier, Carrol Ludwig, and Henry Ellis. (Courtesy of Strasburg Museum, Doug Cooley Collection.)

This house was originally the home and offices of Dr. G.G. Crawford. His daughter Ellen Crawford Hatmaker was a member of the Strasburg Business Women's Club, which organized the first public library in 1959. Ellen Hatmaker's son David donated the house in 1991 for use as the Strasburg Community Library, which is now part of the Shenandoah County Library System. (Courtesy of Laura Ellen Beeler Wade.)

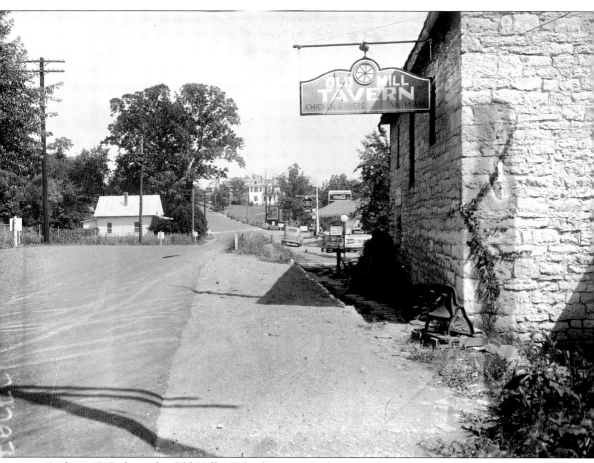

Built in 1797 along the Old Valley Pike (Route 11), the Spengler mill was a target to be burned by Union general Philip Sheridan when his army came through the Shenandoah Valley during the Civil War. The legend is that the miller's wife asked a soldier to escort her to the general, who agreed to spare the mill. It is purported to be one of the oldest standing mills in Virginia. (Courtesy of Shenandoah County Historical Society.)

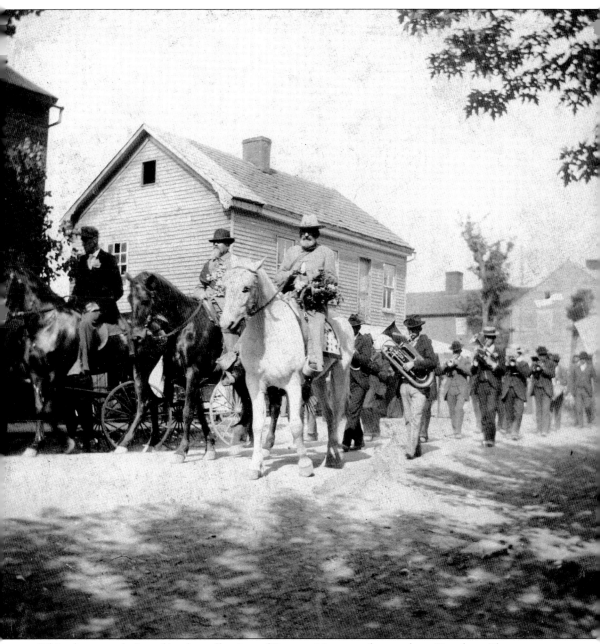

This photograph, found in the collection of Frances Hoover, who taught at Strasburg Elementary School, had writing on the back stating that this was a Memorial Day parade "before 1914." The men on horseback appear to be veterans of the Civil War, which had ended less than 50 years earlier. (Courtesy of Ginger Sager Glading.)

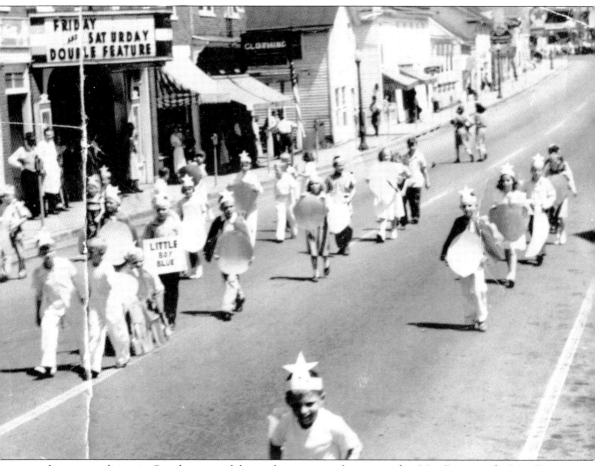

It was a tradition in Strasburg to celebrate the coming of spring with a May Day parade. May Day was an ancient European festival handed down through the generations. Children march down East King Street by the Strand Theater as people watch from doorways and from the start of the parade route on Massanutten Street. (Courtesy of Strasburg Museum, Doug Cooley Collection.)

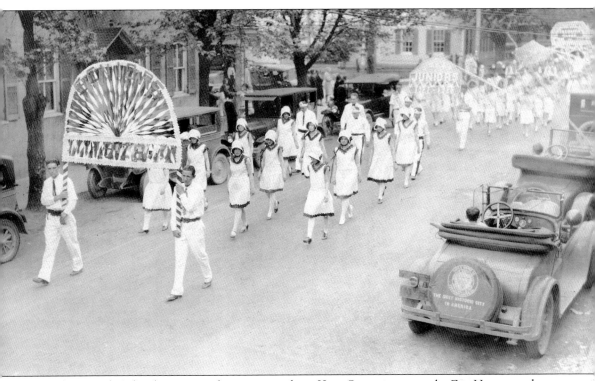

Strasburg High School seniors and juniors march up King Street just past the Zea House on the corner of Holliday and King Streets. The latter proudly hold up their banner: "Juniors 1927–1928." It is likely that at least some of the white dresses were made from silk that the Strasburg Textile Mill allowed employees to take home to sew dresses for their daughters' May Day dresses. (Courtesy of Laura Ellen Beeler Wade.)

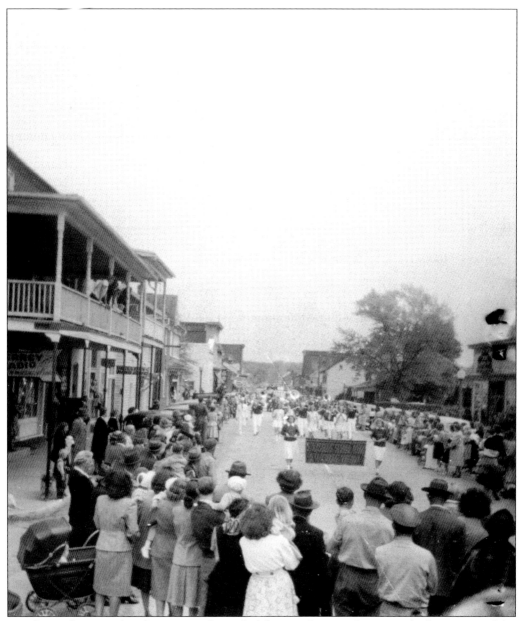
Parade watchers stand in the street at the end of the parade route, lean over the bannisters of the upstairs porches, and hold their babies as the Strasburg High School band marches down West King Street. At right, a sign advertises Keller Radio Repair, and farther up the street, a man in an apron watches from Johnson's Grocery Store. (Courtesy of Laura Ellen Beeler Wade.)

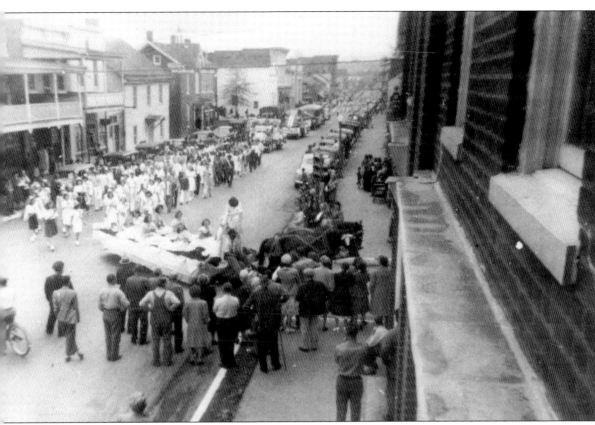

This horse-drawn wagon was decorated for the May Day queen and her court for the May Day parade. As the horses turn off the parade route onto Fort Street, they pass a stoplight on a pole at the corner. This early view reveals how main street stoplights and streetlights once appeared. (Courtesy of Donna Campbell.)

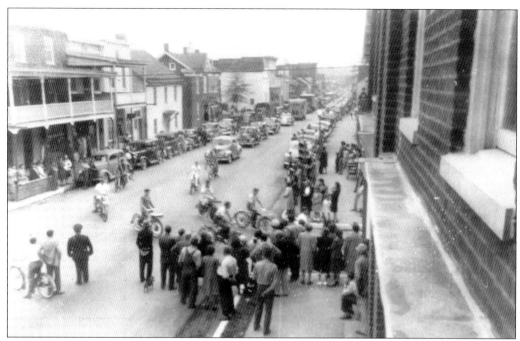

This photograph was taken from the second story of the Kaplan Building, near where the parade ended on West King Street. Children decorated their bicycles with crepe paper and balloons to ride past the parade judges, who would choose the best decorated bicycle. (Courtesy of Donna Campbell.)

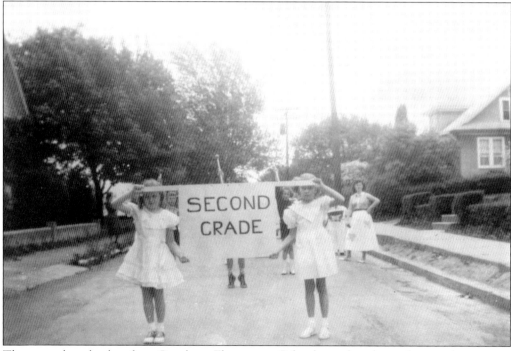

The second-grade class from Strasburg Elementary School marches down the parade route on South Fort Street while a parent chaperone looks on. The girls carrying the sign are wearing their white May Day dresses. (Courtesy of Laura Ellen Beeler Wade.)

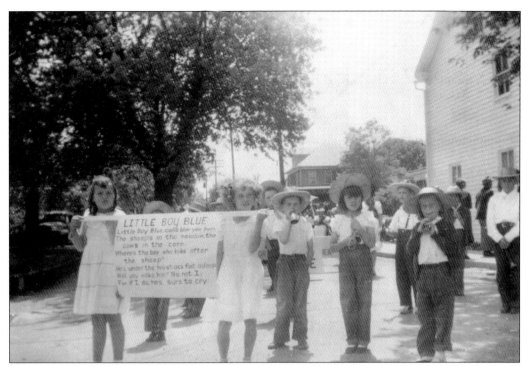

Elementary schoolchildren carry a sign with the words of the nursery rhyme "Little Boy Blue." Children are wearing the traditional white May Day clothes with added costumes reflecting the nursery rhyme. (Courtesy of Laura Ellen Beeler Wade.)

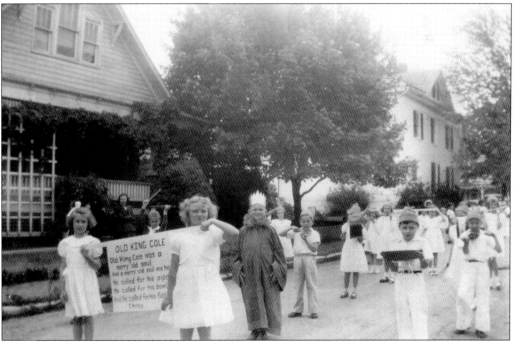

Children march down West Queen Street in the May Day parade carrying a sign with the wording of a popular nursery rhyme, "Old King Cole." (Courtesy of Laura Ellen Beeler Wade.)

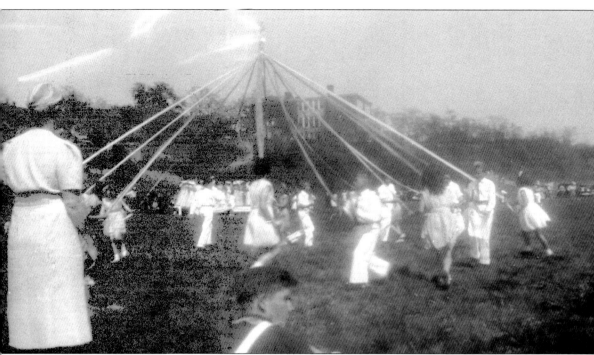

Dancing around a Maypole is an ancient tradition, originally a celebration of spring and a part of Strasburg's May Day festivities. Elementary schoolteacher Eunice Strosnider supervises as the children dance around the Maypole, wearing traditional white clothing and holding ribbons as they circle. Strasburg Elementary School and Strasburg High School can be seen in the background. (Courtesy of Laura Ellen Beeler Wade.)

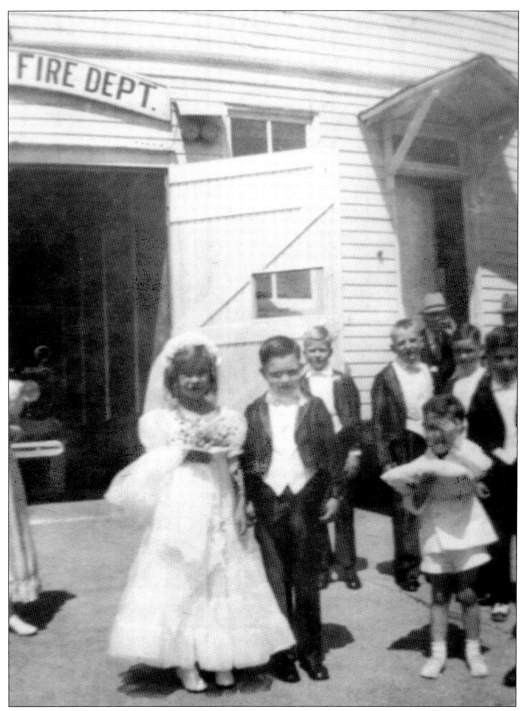

This Tom Thumb wedding party gathered at the town fire department to wait for the parade to begin; groomsmen and ring bearer stand near the groom. Historically, Tom Thumb weddings began in the early 1860s when two "little people" married. The groom, whose stage name was General Tom Thumb, performed for the P.T. Barnum circus. Children performing a pretend wedding for school plays became known as Tom Thumb weddings. (Courtesy of Laura Ellen Beeler Wade.)

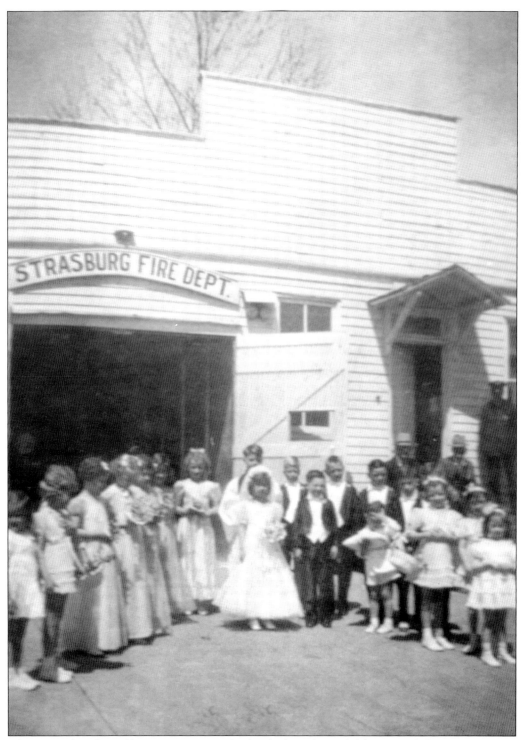

The Tom Thumb wedding was an annual school play where children acted the parts of bride and groom, flower girl, ring bearer, bridesmaids, and parents. Here, the "wedding party" lines up waiting to march in the town's May Day parade. (Courtesy of Laura Ellen Beeler Wade.)

# Two
# Family Business

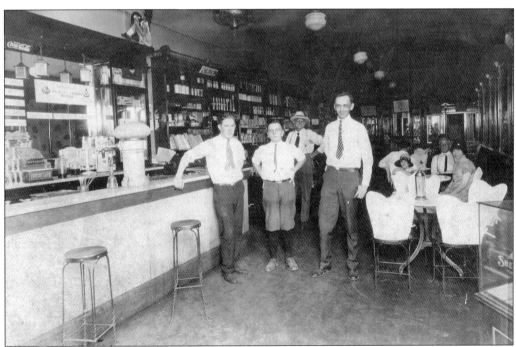

Kneisley Drug Store opened on Main Street in 1906 under the management of Charles Kneisley. Kneisley bought the business from Woodstock pharmacist N.B. Schmitt, adding a soda fountain. He later sold it to pharmacist Allen Lee "Doc" Vaughn, who operated it as Vaughns Drug Store until the early 1970s. His wife, Ruth Vaughn, managed the Greyhound bus service in the drugstore, where passengers could buy a bus ticket and wait for the bus as well as pick up and send packages. It was a popular after-school hangout for teenagers for several generations. (Courtesy of Debbie Lucas Seekford.)

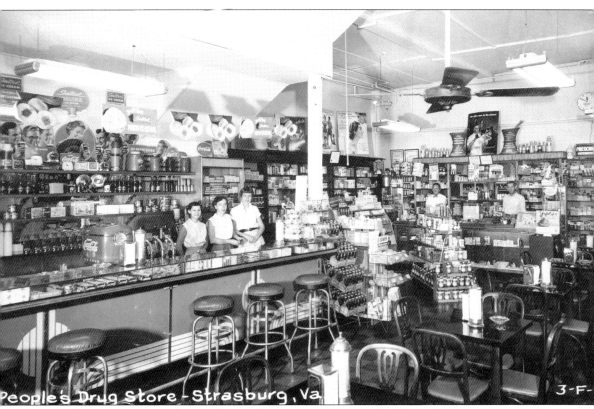

Peoples Drug Store was known for excellent customer service. It delivered prescriptions and kept charge accounts for customers in the years before insurance companies offered prescription drug plans. It did business on King Street for 100 years. When the business closed in 2016, pictures, bottles, and the business sign were donated for a display at the Strasburg Museum. A museum in Luray called Cooters bought the soda fountain to use in its exhibit of a diner. (Courtesy of Betty Barr Colson.)

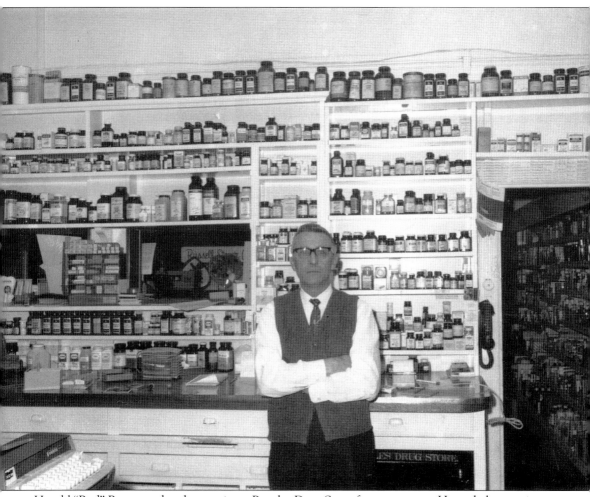
Harold "Bud" Barr was the pharmacist at Peoples Drug Store for many years. He and pharmacist Bob Willey owned the building until 2003. (Courtesy of Betty Barr Colson.)

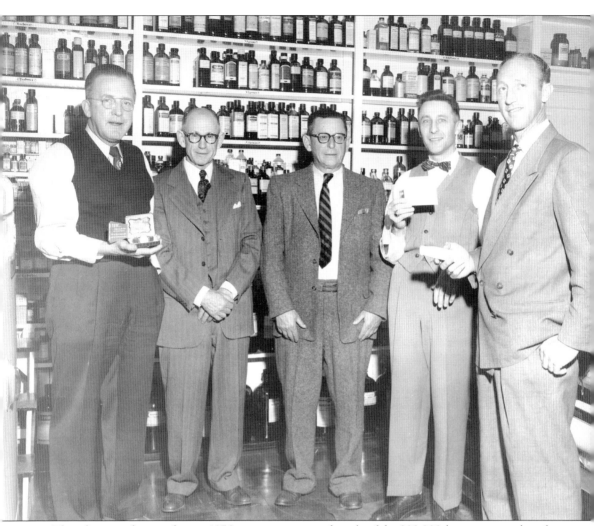

This photograph was taken in 1956 to commemorate the sale of the 200,000th prescription bought at Peoples Drug Store. Pictured are, from left to right, Dr. James H. Sullender, druggist and owner; brothers John S. Miller and J. Ray Miller, original owners; pharmacist Harold R. Barr; and Joseph Howard, then town manager of Strasburg, who happened to be the customer who bought that prescription. (Courtesy of Betty Barr Colson, daughter of Harold Barr.)

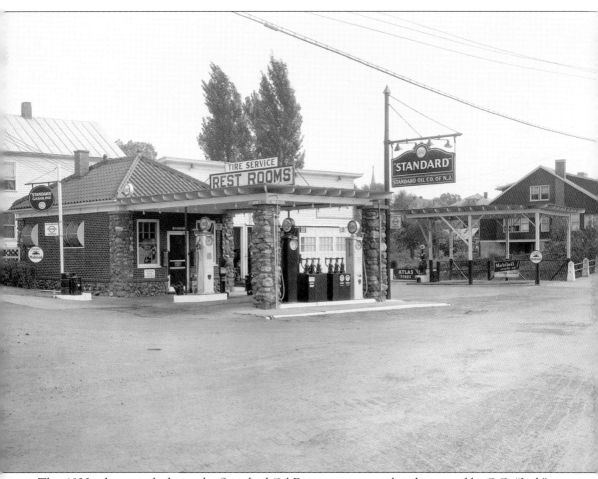

This 1920s photograph shows the Standard Oil Esso station owned and operated by G.G. "Jack" Moyer on the corner of West King and Capon Streets. It was later bought by Doug Bly, then by John Artz. When Artz retired, he sold it to Paul "Tommy" Cameron, who operated under the new name of Cameron Exxon until the 1980s, when it became a Handy Mart convenience store. (Courtesy of Shenandoah County Historical Society.)

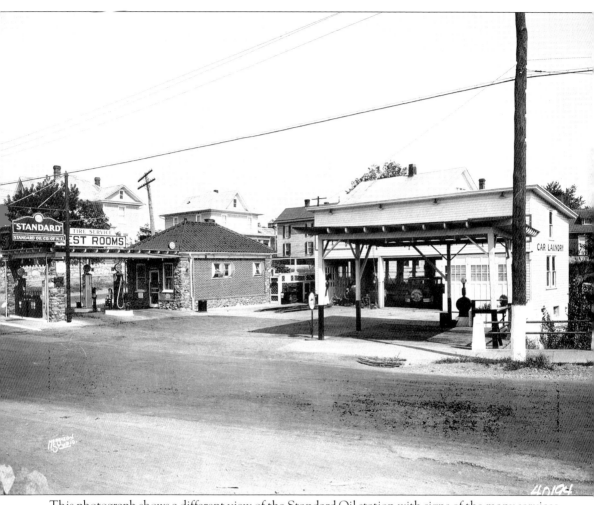

This photograph shows a different view of the Standard Oil station with signs of the many services the station offered. In large lettering on the right side of the garage are the words "Car Laundry;" most people washed their cars in their backyards but for a price could have their cars washed and waxed at the service station. An even larger sign advertises "Rest Rooms," important for travelers in the 1920s and 1930s before interstate rest stops were prevalent. (Courtesy of Shenandoah County Historical Society.)

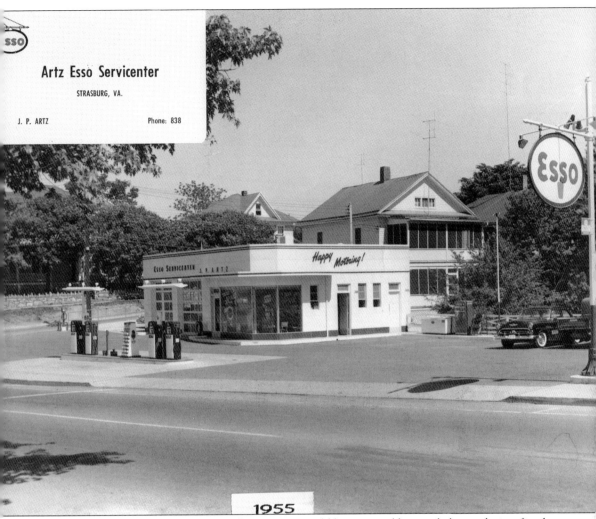

**Artz Esso Servicenter**
STRASBURG, VA.

J. P. ARTZ     Phone: 838

1955

Artz Esso Station was full service, and customers could buy gas and have oil changed, tires fixed, or a car wash in a time before automatic car washes were invented. When people drove their cars into the station, they ran over a rubber hose that caused a "ding" sound in the garage so the employees knew they had a customer. Today, the Esso station is a Handy Mart, a convenience store with self-service gas pumps where customers use plastic cards to purchase gas and wash their own windshields. (Courtesy of Strasburg Museum, Doug Cooley Collection.)

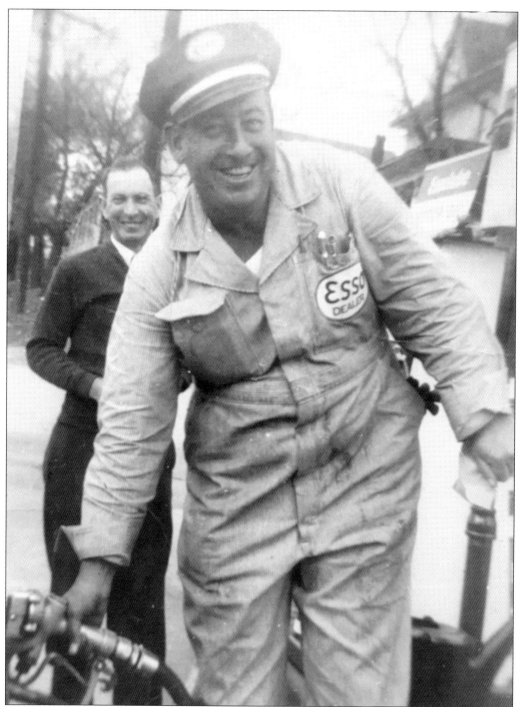
Pictured here in his uniform is John Artz, who owned and operated the Esso service station on King Street. He opened the station just before World War II started and sold it in 1970 when he retired. It was a full-service station where a customer could sit in his or her car while Artz, in his blue striped coveralls, would pump gas, collect money and give change from his pocket, wash windshields, and check the oil. (Courtesy of Sue Artz Grimes.)

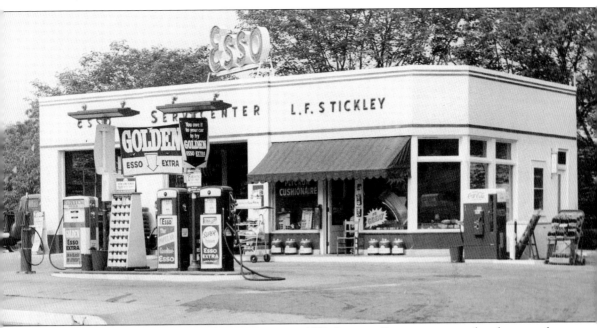

The Esso station on the corner of Massanutten and Washington Streets was owned and operated by the Stickley brothers, later sold to the Holsinger brothers in 1972. Today, it is the only full-service station in Strasburg, appreciated by older people who find it difficult to pump gasoline themselves. Gary Holsinger has operated the station for 50 years, along with his longtime employee Carroll Estep. (Courtesy of Laura Ellen Beeler Wade.)

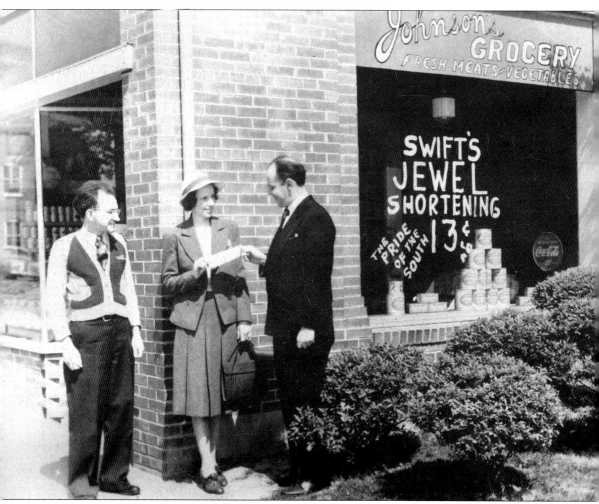

In the 1930s, T.L. "Tom" Johnson owned and managed Johnson's Grocery Store on King Street, next to the post office. His son Marvin later took over the business. Pictured here is a representative of Proctor and Gamble handing a check to local businesswoman Ellen Crawford Hatmaker outside the store as Tom Johnson looks on. The sign in the window advertises a brand of shortening for frying food, claiming it is "the pride of the South." (Courtesy of Strasburg Museum, Doug Cooley Collection.)

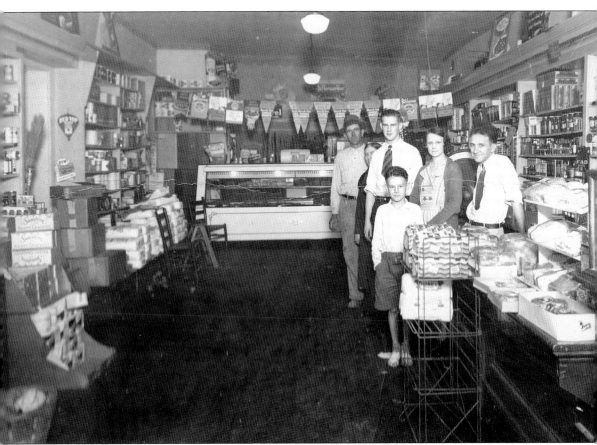

Johnson's Grocery Store was a popular and busy grocery store until the 1970s. Pictured from back to front are friends William R. and Mary Edmonson Pangle and Tom Johnson, his wife, Martha, and their son Marvin. Leaning on the counter behind them is employee Ralph Strosnider. After Marvin Johnson took over the family business, Ralph continued his employment until he retired. (Courtesy of Sheryl Pangle Pifer.)

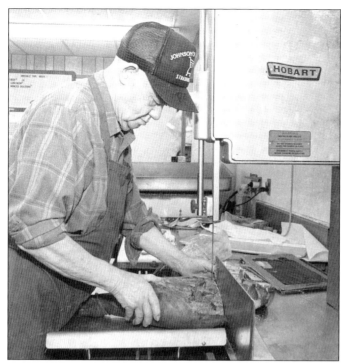

Ralph Strosnider was a longtime employee at Johnson's Grocery Store and managed the meat case in the back of the store. Customers could peer inside the display case at the freshly ground hamburger and other cuts of meat and choose what they wanted. Ralph would then weigh the requested amount and wrap it in paper, and the customers would take it to the front counter. There the customers would either pay for it or Marvin Johnson would put it on their bill. (Courtesy of Park Hottel.)

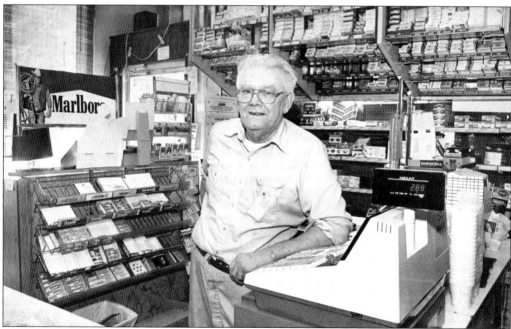

Marvin Johnson, surrounded by packages of cigarettes, waits at the cash register for customers in his grocery store on King Street. Customers would pay by cash or check at Johnson's Grocery Store, or sometimes Johnson would put it on their bill. Customers would then pay weekly or monthly depending on their payday. Many Strasburg residents would telephone the store to order their groceries, and store employees would deliver to their homes, a service that has been utilized again during the recent pandemic. (Courtesy of Park Hottel.)

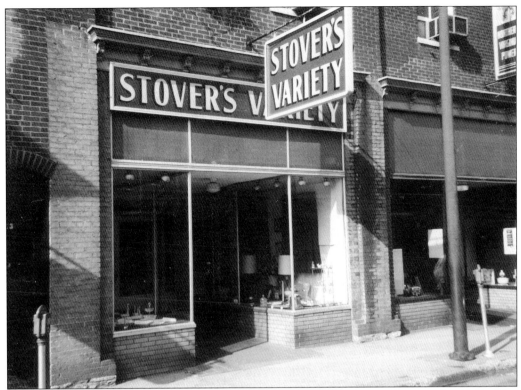

William "Bill" Stover Sr. and his wife, Evelyn, operated Stover's Variety Store in the 1960s. The building on King Street had previously been Rosson's 5 and 10 Cent Store, operated by Lloyd and Bertha "Doll" Rosson, and later became Slanton's Five and Dime. After the Stovers closed the store, cobbler Byrd Barrick established a business in this building as Barrick's Shoe and Variety Shop, where he also sold a variety of items in addition to repairing shoes. Barrick's business card advertised "glassware, fabrics, sewing notions, antiques, gifts and collectables." The building later was the location of Arthur & Allamong Law Offices and today is the office of Brandon G. Keller, Attorney at Law. (Courtesy of William "Bill" Stover Jr.)

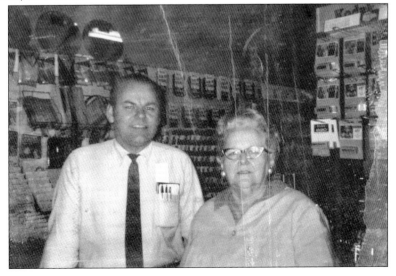

William "Bill" Stover Sr. and employee Marie Williams are pictured here inside Stover's Variety Store. Items for sale can be seen behind them, including 620 film and flashbulbs for instamatic cameras, 45 rpm records, and jean patches. It indeed had a variety of items to choose from. (Courtesy of William "Bill" Stover Jr.)

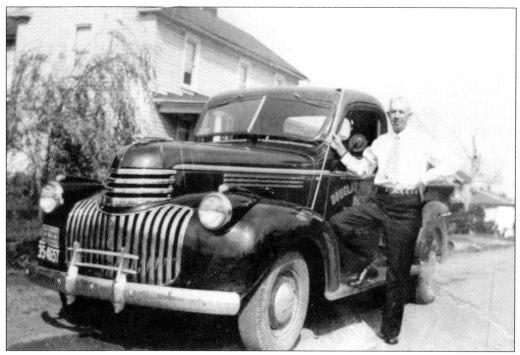

Douglas Williams stands beside the vehicle he used to deliver ice from Williams General Store and Ice, a family business. In the 1930s and early 1940s, Williams delivered large blocks of ice to area residents to place in their iceboxes to keep food cold before the invention of electric refrigerators. (Courtesy of Sharon Bly Ferguson.)

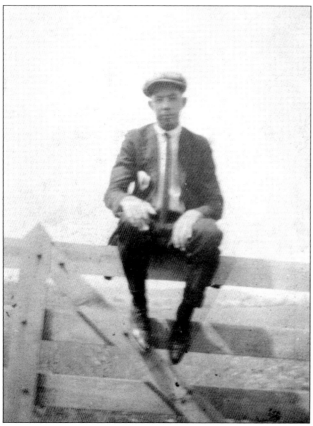

Douglas Williams, one of five sons of Arch C. and Lucy Belle Williams of B Street (later Branch Street), sits on a fence on the family property around 1920. Doug and his brothers all built homes around the Williams homeplace on the west end of town. (Courtesy of Gloria Jean Williams Igram.)

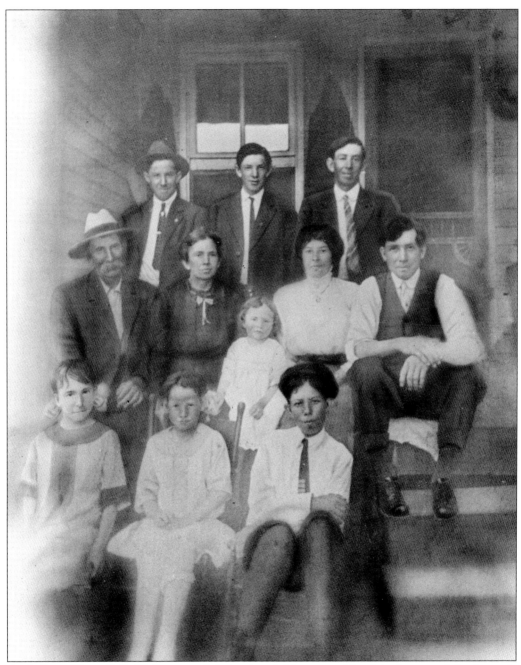

Arch C. and Lucy Belle Williams and their nine children posed for this photograph in the early 1900s. Arch and his sons operated Williams General Store on the west end of town. The store account book provided by granddaughter Margaret Williams Bromley listed goods sold to O.G. Borden and H.P. Smith in June 1901: flour for 65¢; rice, 3¢; coffee, 10¢; sugar, 6¢; and butter, 10¢; they also bought lard, envelopes, and beans. (Courtesy of Dorothy Williams.)

The bride in this photograph is Mary Richard, daughter of B.F. and Molly Richard, with the wedding party and Richard family gathered in front of the Richard home at Del Ray Farm. The historic brick house, built in 1898, is still owned by descendants. Over the years, the Richards had an apple orchard and dairy farm, raising cattle and pigs. Today, great-granddaughter Kelsie Mast lives and works on the farm in her greenhouse and florist business, Petal Pushers. (Courtesy of Diane Artz Furlong.)

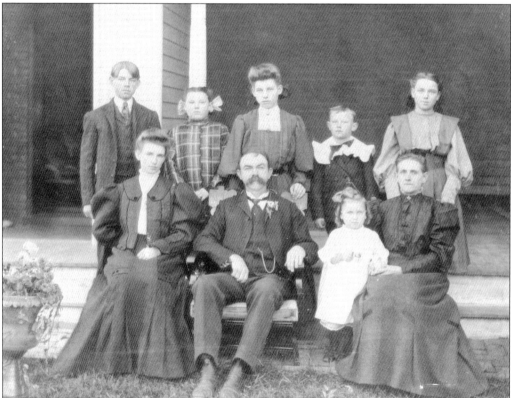

The Richard family poses for a portrait around 1905. Pictured are, from left to right, (first row) Mary Hoover, Benjamin Franklin Richard, Virginia Cuneo, and Mary Etta "Mollie" Spengler Richard; (second row) Harry "Jake" Richard, Jess Coffman, Annie Adelia Artz, Fitzhugh "Fitz" Richard, and Nell Updyke. (Courtesy of Diane Artz Furlong.)

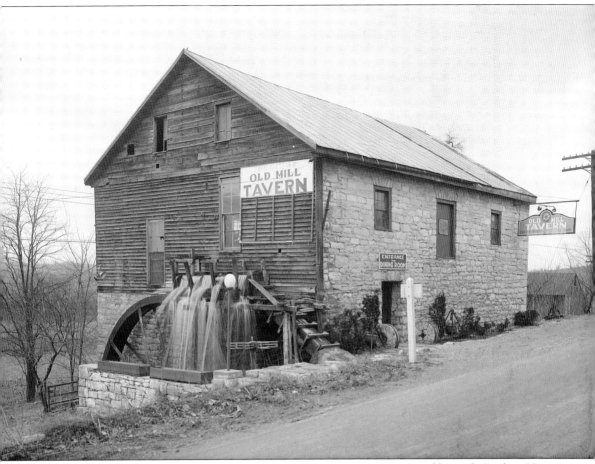

The Old Mill was renovated into a restaurant by George Harry Pappas and his wife, Pauline Hart Pappas, in 1938. Their daughter-in-law Peggy Pappas later managed it as the Old Mill Tavern, and in later years, it was opened and closed by several others; Sarah Mauck operated the Old Mill Restaurant from 1998 until 2007. It was a popular restaurant in the 1940s and 1950s where couples could go for dinner and dancing in a rustic setting with red gingham curtains and tablecloths. Today, the building is the headquarters of the Strasburg Eagles Club. (Courtesy of Shenandoah County Historical Society.)

The Dropover Restaurant got its name because the back of the restaurant hung over the hillside. It was located on West King Street across from what is now Handy Mart, on the edge of the highway. It was also called The Tavern. (Courtesy of Strasburg Museum, Doug Cooley Collection.)

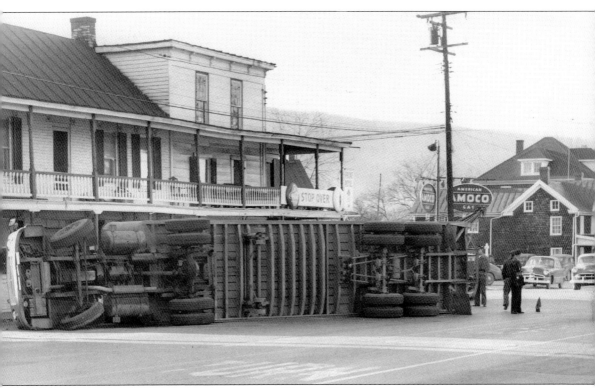

A tractor trailer truck wrecked at the corner of King and Massanutten Streets in the 1950s. A sign for the Stop Over is the only indication a restaurant is located there, as it is hidden by the large trailer. The upstairs porch was removed from the building years ago, and the original logs of the structure are exposed. The Stop Over later became Sylvia's Restaurant, owned and operated by Sylvia Smith. When Sylvia's Restaurant closed, the space became the first ethnic restaurant in town, Cristina's Mexican Restaurant. It is now the Strasburg Flea Market. The Amoco service station on the opposite corner, first owned and operated by Tracy Lineberg and then the Kibler family, is also hidden. Only the tall Amoco sign shows above the wreckage. (Courtesy of Park Hottel.)

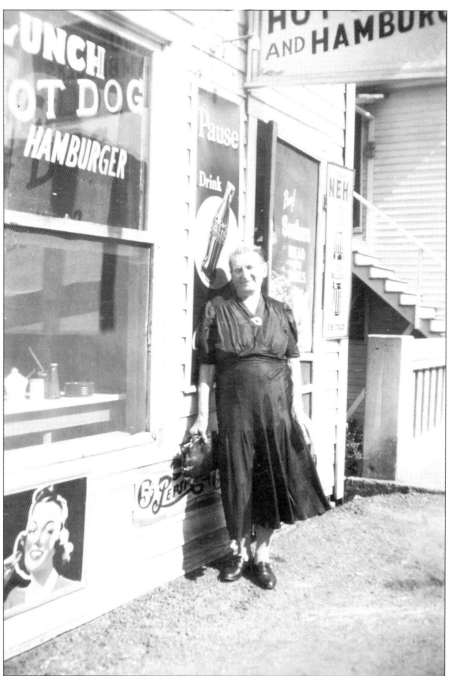

One of the forgotten restaurants on the main street in the 1940s, Jimmy the Greek's was located on the site that is now a Dollar General next to the bridge over the Town Run; the same concrete railing of the bridge exists today at the pedestrian crossing. Anna Virginia "Nan" Hoffman is surrounded by popular advertising signs of the time, a classic Coco-Cola sign at her head, Pepsi sign at her feet, a Nehi soda sign behind her, and an advertisement for Southern bread on the window. People who remember this King Street restaurant still praise the hot dogs and hamburgers James Conelos sold for 5¢. (Courtesy of George Hoffman.)

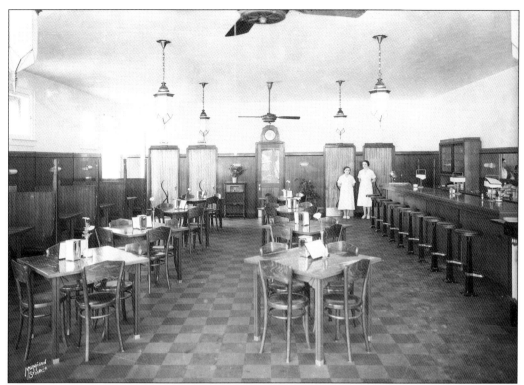

Two waitresses, Neva Brill Clem and Leota Connor Himelright, pose inside the Virginia Restaurant on the corner of King and Holliday Streets (now the site of Sager Real Estate). The popular Virginia Restaurant was the family business of Clarence "Buggy" Brill, his brothers Pearly and Obadiah "Obie," and Obie's wife, Louise, from the 1930s until it closed in the 1970s. The restaurant was popular with families for its Sunday dinners after church as well as a great place for kids to gather on Friday nights after the football game. (Courtesy of Shenandoah County Historical Society.)

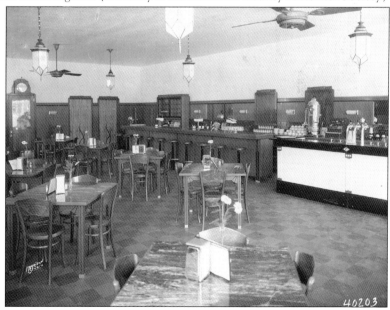

The door on the left was a phone booth complete with a wooden bench for sitting during long conversations. There was no dial tone until a dime was put in the slot, and then the number could be dialed on the rotary phone. (Courtesy of Shenandoah County Historical Society.)

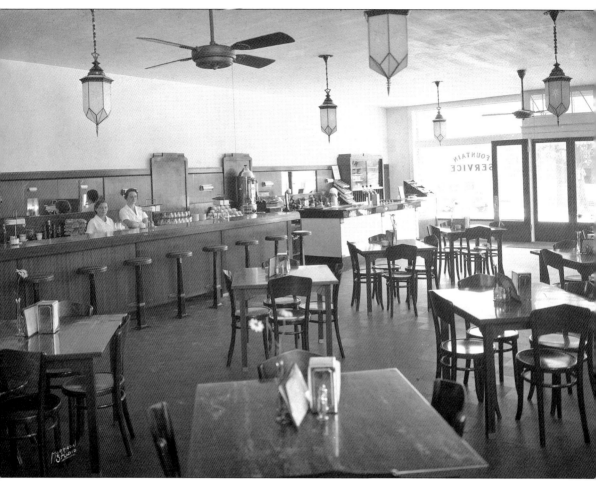

Buggy Brill kept a watchful eye over the restaurant and was known to be good to his waitresses and strict with the teenagers when they behaved badly. During the Great Depression, hobos would come to the back door and ask politely for food. They were homeless men traveling around the country looking for jobs and had no money to pay. Brill would instruct his waitresses to give them a bowl of soup and a glass of ice water, and the grateful men would then go on their way. The large window in the front advertised "Fountain Service," where customers could buy soft drinks and milkshakes. (Courtesy of Shenandoah County Historical Society.)

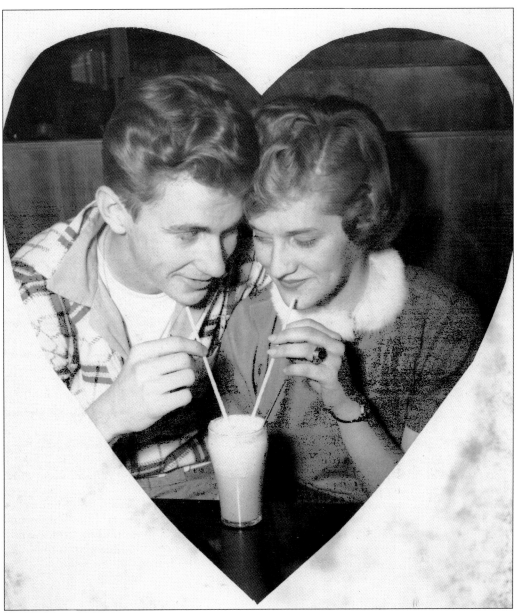

The Virginia Restaurant was a favorite teenage hangout, a place to take a date for a snack or to meet friends. On Friday nights after a school football game, the restaurant was typically filled with teenagers. Pictured here are two teenagers, Larry Devers and Jean Troxell. (Courtesy of Park Hottel.)

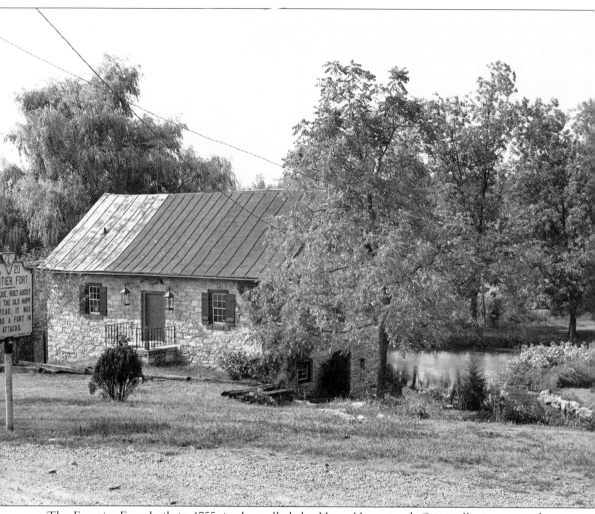

The Frontier Fort, built in 1755, is also called the Hupp Homestead. Originally, it was used as a distillery, which utilized the spring that runs under the building. In later years, a restaurant called the Frontier Fort was established by Gene Richard Hupp, then managed by Sally Kehoe in the 1960s. Photographer Frank Hupp used the building for his Frontier Fort Studio business. It is now a residence. (Courtesy of Park Hottel.)

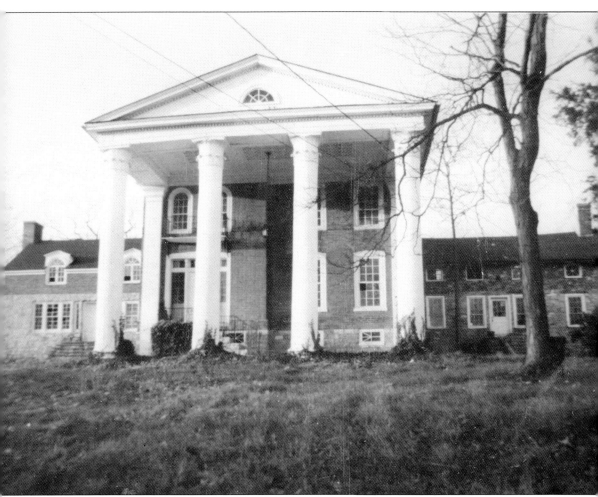

The Hupp Mansion, located on North Massanutten Street, was the residence of George Franklin and Catherine Spengler Hupp. At one time, this property consisted of over 1,000 acres and included Hupp's Hill and Crystal Caverns. Union brigadier general James A. Shields, major general Nathaniel P. Banks, and major general Philip H. Sheridan used this mansion at various times as their headquarters during the Civil War, as did Confederate general Stonewall Jackson. (Courtesy of Park Hottel.)

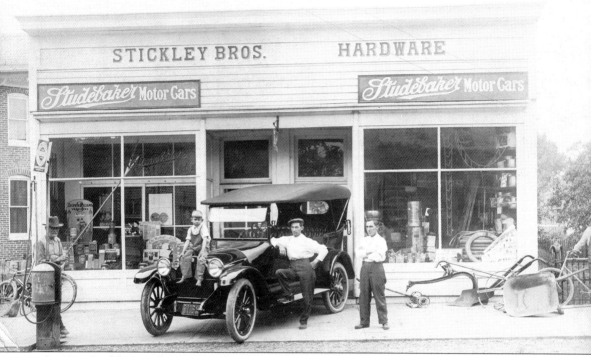

In 1914, Stickley Brothers General Hardware & Automobiles was the first hardware store in this building on West King Street. The year on the license plate of the Studebaker car parked on the sidewalk is 1916. The young boy sitting on the car is Linden Stickley, son of Abe Stickley and nephew of Omar Stickley, the brothers who owned the hardware store and are standing next to the car. The man on the left wearing a hat is unidentified. The store sold gasoline and other items needed for car owners. A sign for Chi Namel, a car varnish that was popular in the early 1900s, can be seen in the front window, and hand garden plows, wheelbarrows, and a push lawn mower line the front of the building. (Courtesy of Laura Ellen Beeler Wade.)

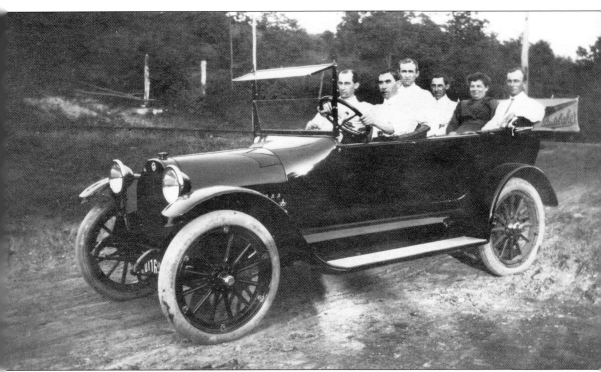

Tom Stickley is behind the wheel with his brother Abe Stickley beside him; in the back are other members of the family—Angus, Omar, Laura, and Guy. The Stickley boys opened a hardware store and sold cars in 1914. According to a *Strasburg News* article in 1917, Omar was in the plumbing and heating business and his brother Abe was in the automobile and garage business before they formed Stickley Brothers. (Courtesy of Laura Ellen Beeler Wade.)

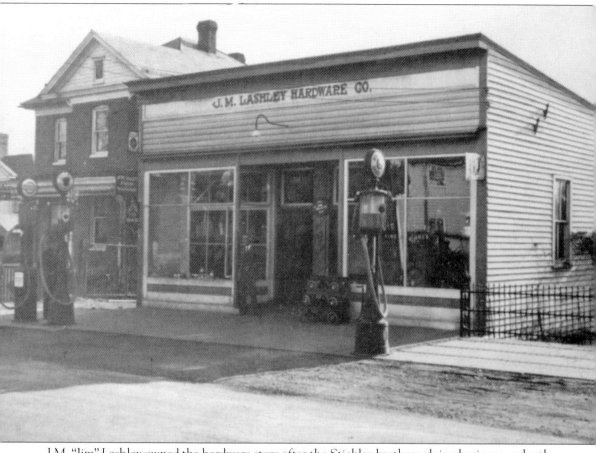

J.M. "Jim" Lashley owned the hardware store after the Stickley brothers, doing business under the name J.M. Lashley Hardware Company. The number of gasoline pumps was increased to four. Raymon Tamkin next bought the business, and Tamkin Hardware hired Sam Artz Sr. in 1941. When Tamkin retired, Artz took over the business and operated as Artz Hardware from 1956 until 2005. (Courtesy of Strasburg Museum, Doug Cooley Collection.)

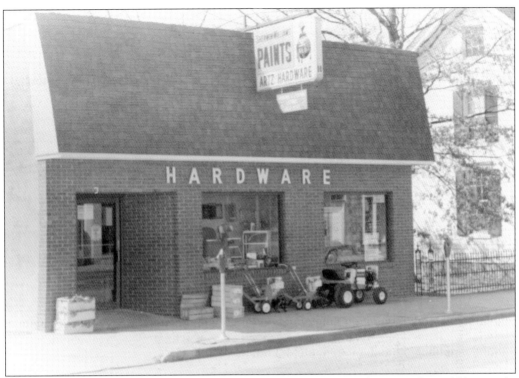

Artz Hardware was a family-owned and -operated hardware store where people could buy tools, bulk seed, housewares, wallpaper, paint, and canning supplies as well as hunting and fishing licenses. It also sold lawn mowers, guns, ammunition, and fishing tackle. Every December, the front sidewalk would be lined with live Christmas trees. Sammy Artz Sr. took the store over in 1956 and ran it with his wife, Juanita, and son Sam until 2005 when he retired. Pot Town Organics now operates a business where customers can still buy many of these same gardening and canning supplies. (Courtesy of James Allamong.)

Eugene "Punk" Painter and his wife, Dorothy, stand next to their car in the driveway of their home on A Street (now Ash), where Painter had a print shop. Painter Print Shop printed the large posters announcing the arrival dates of the annual carnivals, tickets for the carnival and fundraising raffles, and targets for the local shooting matches. Local restaurants bought their waitress notepads from Painters Print Shop. When children in town held backyard carnivals to raise money for muscular dystrophy, Painter would give them scrap paper and poster board for free to advertise their carnivals and to make signs for the games. (Courtesy of John P. Painter.)

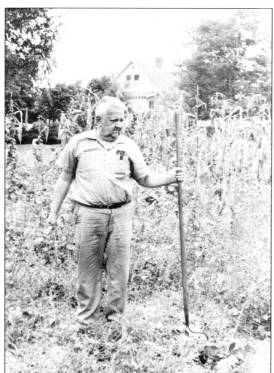

Eugene "Punk" Painter stands with his garden tools in his vegetable garden at his home on Ash Street, next to his print shop. Sometime after this photograph was taken, Painter suddenly became ill and could not garden anymore. After he passed away, his son John found his garden hoe had grown into the tree where his dad had propped it, intending to return to his garden. (Courtesy of John P. Painter.)

In 1912, E.E. Keister purchased a weekly newspaper called the *Strasburg News*, later buying other weekly newspapers in the surrounding area and eventually creating the *Northern Virginia Daily* in 1932. This building, the current location of the *Daily* offices, was built in 1922. (Courtesy of Shenandoah County Historical Society.)

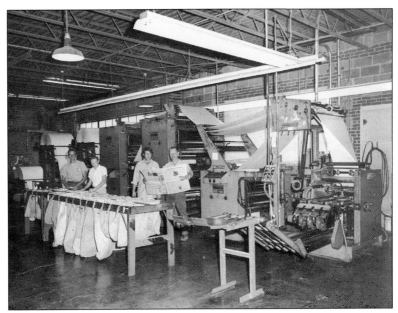

Pictured from left to right, Lloyd Elbon, Charlie Utterback, Dave Hunt, and Jim Braithewaite work the night shift in the *Northern Virginia Daily* pressroom to print the paper in time for early morning delivery. The *Daily* was printed in Strasburg until the Keister family sold the paper in 2012. (Courtesy of Park Hottel.)

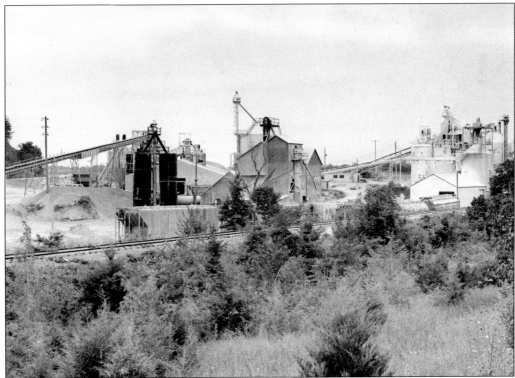

In the Strasburg area, there were five limestone plants in the early 1900s where rock was quarried and processed into lime. Many Strasburg men worked the quarries to make a living to support their families. In 1961, Virginia Hinkins Cadden wrote in her book *The Story of Strasburg* that Strasburg lime had been tested and was "98% pure" and used for building, chemical, and agricultural purposes. Many Strasburg families used ground lime to cover potatoes stored in cellars and regularly tossed it into privy pits to reduce odor. (Courtesy of Park Hottel.)

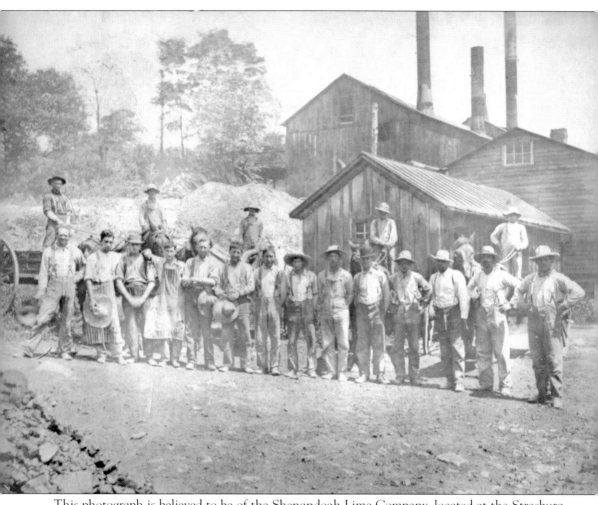

This photograph is believed to be of the Shenandoah Lime Company, located at the Strasburg Junction, which in 1892 was the first limestone quarry in the area. In 1917, the company was one of the largest depositors of the Massanutten Bank. (Courtesy of Park Hottel.)

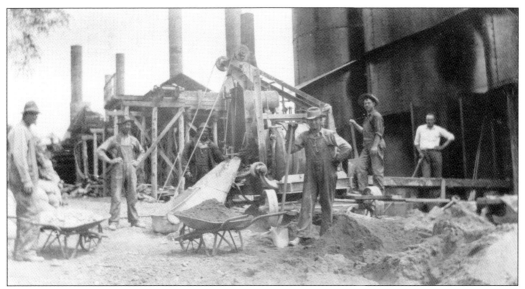

Benton "Bent" Boyer and coworkers pause with their shovels for a photograph at the Powhatan Lime Kiln at the Strasburg Junction. Boyer, wearing bib overalls like most of the men, is standing behind a wheelbarrow; to the right of him is what appears to be a crushing machine. (Courtesy of George Hoffman.)

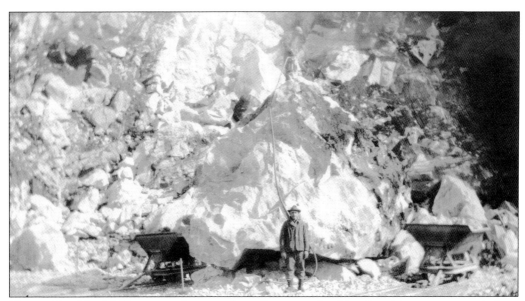

George Franklin Hoffman stands near a huge limestone boulder; its white appearance is from the high degree of calcium carbonate. The Strasburg area quarries had some of the best-quality limestone found in the world. Note the men on top of the boulder with either a pneumatic drill or a hammer. (Courtesy of George Hoffman.)

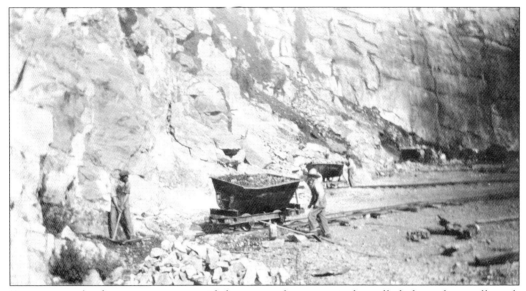

Two men are loading a quarry cart with limestone fragments to be pulled along the small track either to the kiln and crusher processing or to the berm where unusable material was placed, growing larger and higher each year. (Courtesy of George Hoffman.)

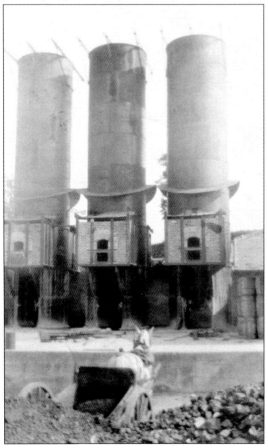

This photograph at the Powhatan Lime Kiln depicts how horses and mules were used to pull two-wheel carts, supplying much of the heavy lifting work at the quarries until replaced by trucks after World War II. (Courtesy of George Hoffman.)

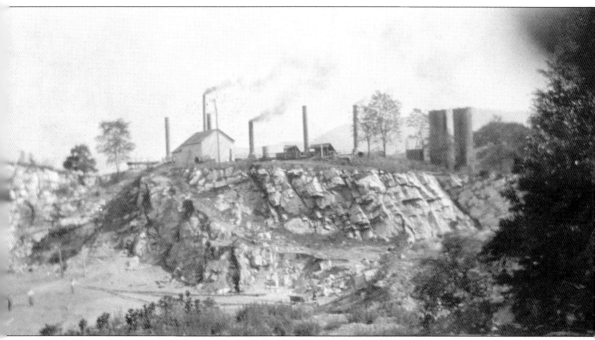
As the hillside was mined for limestone, the landscape changed forever, leaving large pits and spoil piles. Massanutten Mountain can be seen in the background. (Courtesy of George Hoffman.)

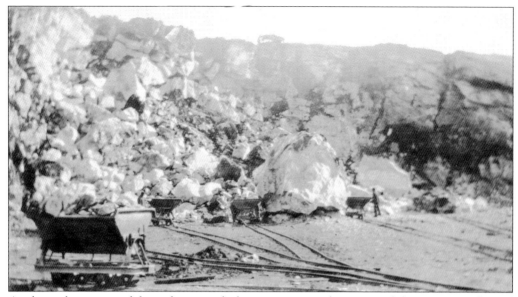

As the rock is quarried from the ground, the remaining rock is exposed, leaving its geological history. Here, the miners have laid tracks on the bottom of the pit to move the mining carts. A rock wall forms on the edge, growing taller as the mining goes deeper. Several of these large mining pits eventually were abandoned and filled with water and became local swimming holes. One area quarry was commercialized in the 1980s and operated as Half Moon Beach until closing in 2007. (Courtesy of George Hoffman.)

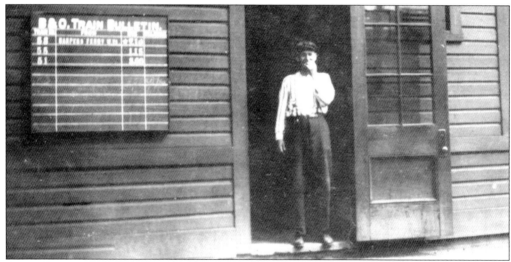

Around 1941, railroad agent Charles Chandler poses for a photograph in the doorway of the train depot at the Strasburg Junction. According to Bob Cohen in his book *A Trip by Rail in the Shenandoah Valley*, Strasburg Junction was created when the Baltimore & Ohio Railroad (B&O) opened the Winchester and Strasburg line in June 1870, which provided an interchange between the Orange, Alexandria, and Manassas lines and the B&O. A mile and a half from the town of Strasburg, the trains transported passengers, earthenware made in the many Strasburg potteries, apples and other locally grown produce, and ground lime and stone quarried from the Powhatan Lime Kiln. As the use of automobiles increased and roads improved, the need for passenger trains lessened. (Courtesy of Betty Barr Colson.)

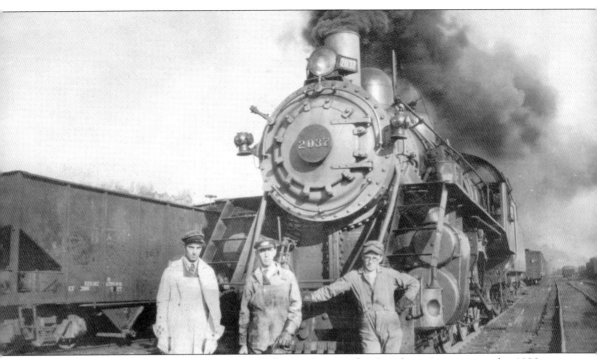

Three unidentified men stand in front of a locomotive at the Strasburg Junction in the 1930s. Rail power allowed the lime produced at the Powhatan plant to be shipped to markets around the country. (Courtesy of Betty Barr Colson.)

These three men founded Crystal Caverns and Zoo about 1922. They are, from left to right, Bruce Franklin Hupp, Frank H. Miller, and Archie Carlyle Painter. After the Caverns closed in the 1960s, Frankie Howard turned the former museum into a popular skating rink until the early 1970s. Wayside of Virginia built and operated a Civil War museum on the property until 2010, when it was leased to Cedar Creek Battlefield Foundation, then to the Shenandoah Valley Battlefields Foundation, where local Civil War history is on display. Today, it is the home of the Town of Strasburg Visitor Center. (Courtesy of Rolen Hupp Painter.)

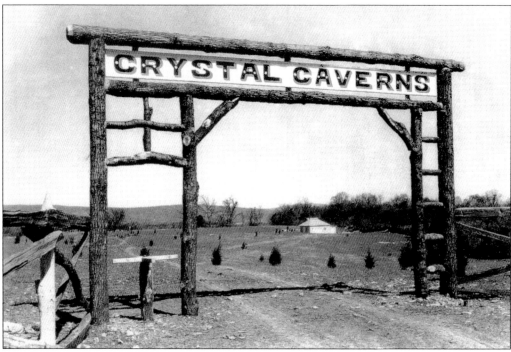

This 1922 photograph shows the gate entrance to Crystal Caverns and Zoo, which was at Hupps Hill near the current-day Food Lion. The caverns were discovered by early settlers in the area and used by soldiers on both sides of the Civil War. The zoo, according to James A. Poland, son of the owner and operator E.W. Poland, had "leopards, poisonous snakes, including copperheads and rattlers, deer, coyotes, monkeys, an eagle, a lion and a big black bear." (Courtesy of Rolen Hupp Painter.)

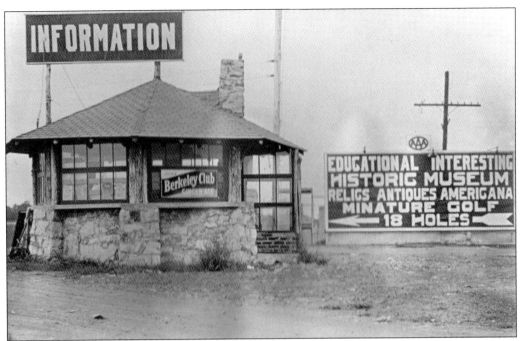

The information booth at the entrance to the caverns and zoo advertised "Educational, Interesting, Historic Museum, Relics, Antiques, Americana, Minature [sic] Golf, 18 Holes." Crystal Caverns was a popular tourist attraction and a favorite of area residents. (Courtesy of Rolen Hupp Painter.)

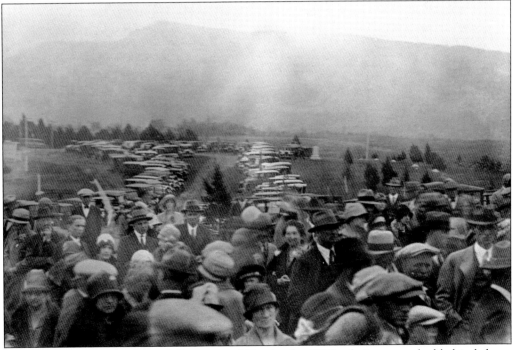

A crowd gathers at the Crystal Caverns and Zoo in the 1930s, their cars parked behind them. Massanutten Mountain can be seen in the background. (Courtesy of Strasburg Museum, Doug Cooley Collection.)

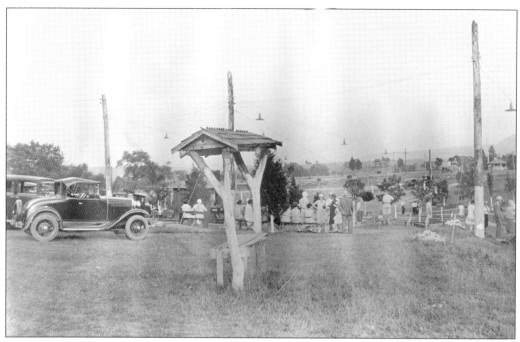

E.W. Poland, who operated the caverns and zoo, kept what was described as a "big, black bear" in the zoo. Audiences flocked to watch Poland put on a show wrestling with the bear. In this photograph, people are gathering, perhaps to watch Poland and the bear wrestle or for live music. (Courtesy of Strasburg Museum, Doug Cooley Collection.)

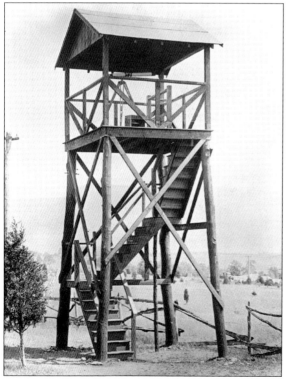

This photograph shows one of the observation towers at Crystal Caverns and Zoo in the 1920s; it was used for viewing nearby Civil War battlefields, Signal Knob on Massanutten Mountain, and the town through a telescope located on the top. This tower, according to family historian Rolen Hupp Painter, was erected during the Civil War by Union general Nathaniel Banks to watch for Confederate troop movements and was not removed until the late 1940s. The location of Strasburg's World War II watch tower is unknown, but it is likely that this tower was used by volunteer residents in the Civil Air Patrol to watch for incoming enemy planes since it existed at that time. (Courtesy of Strasburg Museum, Doug Cooley Collection.)

# Three
# SCHOOL DAYS

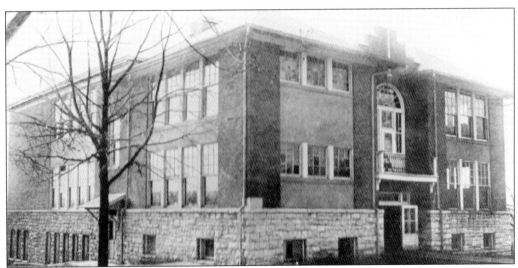

The right side of the school building on High Street was constructed in 1910 for all grades. In 1928, a new high school was built to the left, and the older section then became the elementary school for grades one through five. Later, the two buildings were joined by a new gymnasium and cafeteria, and in 1959, the new high school was constructed where it is today on Holliday Street. After new elementary and middle schools were built on Sandy Hook Road, the High Street school closed. The building is now the Strasburg Mennonite Church. (Courtesy of Strasburg Museum, Doug Cooley Collection.)

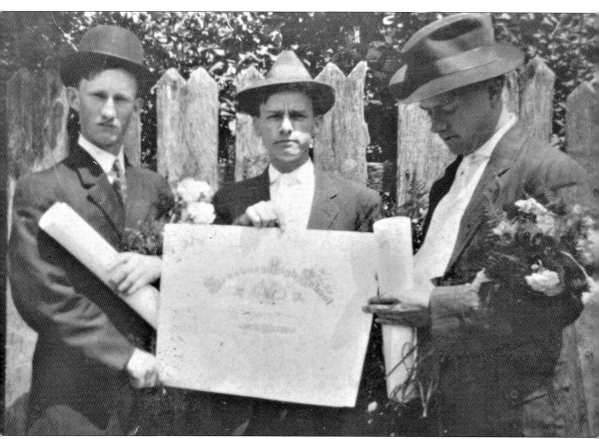
These three young men are the first to graduate from Strasburg High School in 1910. Pictured are, from left to right, Col. John Hepner, Frank Stover, and Stanley McInturff. At that time there was one building for the elementary and high school classes. (Courtesy of Strasburg Museum, Doug Cooley Collection.)

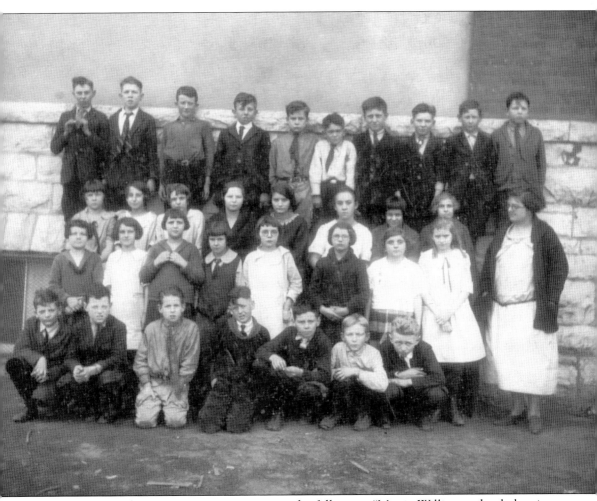

On the back of this group picture was written the following: "Mattie Williams school class in 1923, Miss Clara Keister Teacher." The students are posed in front of the older part of the school on High Street where Mattie Williams Cameron (third row, fourth from left) graduated high school. (Courtesy of Kathy Combs Kehoe.)

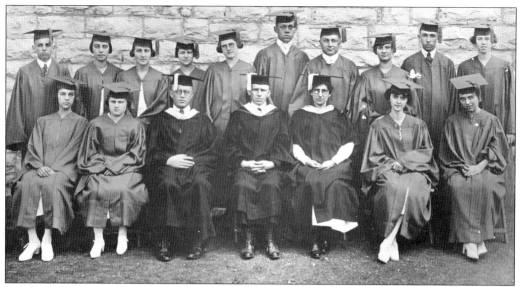

The Strasburg High School graduating class of 1920 poses in front of the school. Pictured are, from left to right, (first row) Florence Stickley, Sarah Stickley, Clark Copp, Arthur Ramey, Frances Jenkins, Lois Chandler, and unidentified; (second row) Raymond Stickley, Pauline Lichliter, Susie Kneisley, Angina Keller, Elizabeth Green, Mose Snarr, Denzil Wisecarver, unidentified, Frank Chandler, and Effie Payne. (Courtesy of Strasburg Museum, Doug Cooley Collection.)

This photograph shows the Strasburg High School sophomore class of 1925. The students are Evelyn Bell, Anne Bly, Elsie Boehm, Elizabeth Brown, Cecil Burner, Elizora Burner, Rebecca Cooley, James Crawford, Anna Dawson, Vernon Frederick, Geneva Funk, Edward Hopewell, Lena Hill, Frances Hoover, Virginia Keyes, Ethel Laing, Edyth Lineburg, Catherine Ludwig, Frances Millner, Rosella Orndorff, Martha Painter, Nelson Robinson, Anna Snapp, Barbara Stickley, Rubye Stickley, Ruth Stickley, Vernon Stickley, Vivian Stickley, Mary Walters, Agnes Weaver, and Thelda Woodward. (Courtesy of Strasburg Museum, Doug Cooley Collection.)

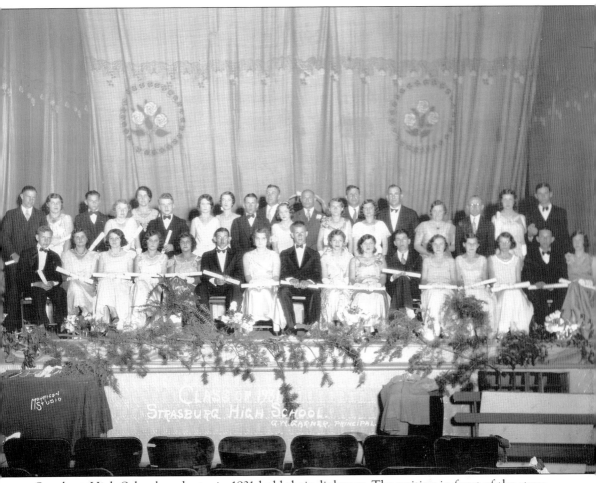

Strasburg High School graduates in 1931 hold their diplomas. The writing in front of the stage reads: "Class of 1931, Strasburg High School, G.W. Garner, Principal." Local historian Doug Cooley identified the students with surnames such as Artz, Kibler, Updyke, Cooley, Ludwig, and Rutz as well as home economics teacher Louise Colley and teacher Harry Crim. (Courtesy of Strasburg Museum, Doug Cooley Collection.)

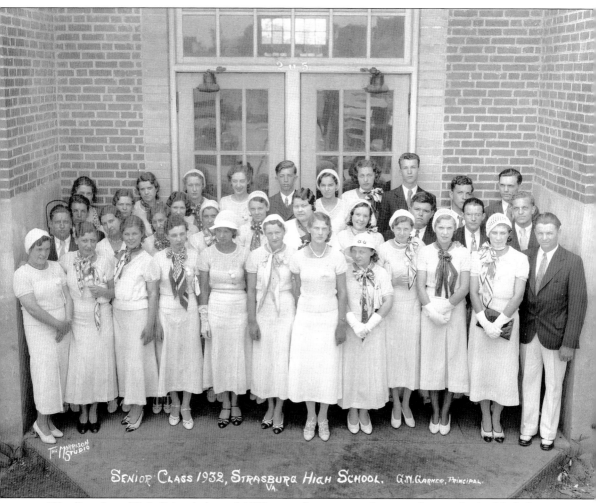

The Strasburg High School class of 1932 poses for a group photograph outside the High Street building. The principal was C.W. Garner. (Courtesy of Laura Ellen Beeler Wade.)

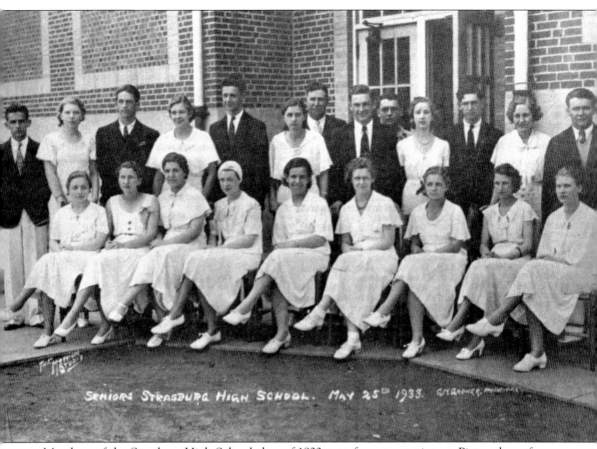

Members of the Strasburg High School class of 1933 pose for a group picture. Pictured are, from left to right, (first row) Frances Wilkins, Azalea Carrier, Ruth Stafford, Nancy Riddleberger, Miriam Wolfe, Nancy Smith, Pauline Henson, Doris Strickler, and Agnes Crabill; (second row) Bob Funk, Carmen Barrow, Fred Kline, Mary Copp, Morton Wolfson, Kathryn Kibler, principal G.W. Garner, Bill Wake, Joe Mitchell, Phyliss Stickley, Granville Bly, Edna Stickley, and Mark Strosnider. (Courtesy of Strasburg Museum, Doug Cooley Collection.)

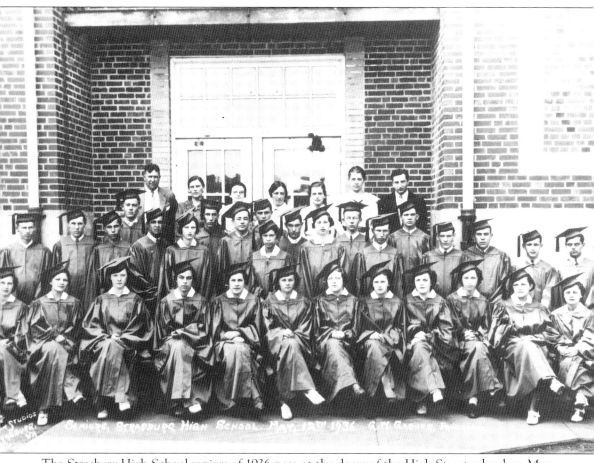

The Strasburg High School seniors of 1936 pose at the doors of the High Street school on May 12, 1936. Their principal's name on the front of the photograph is G.W. Garner. (Courtesy of Laura Ellen Beeler Wade.)

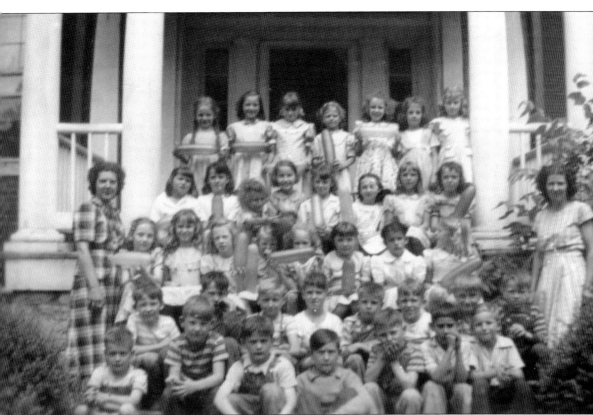

Second graders in Virginia H. Beeler's class pose for a group picture on the porch steps of Elizabeth Fisher's home, Long Meadow. Beeler stands at left, and Madolyn Kitchin is on the right. Pictured are, from left to right, (first row) Michael Vann, Lany Clem, unidentified, Marvin Mumaw, and three unidentified; (second row) Billy Bryant, Clifton Pence, Tommy Simmons, Charlie Thome, Donnie Drummonds, and three unidentified; (third row) Shirley Rinker, Roselle Miller, Peggy Putnam, Sylvia Mayhew, Rebecca Steele, Dorothy Boyer, Mary Catherine Strosnider, and unidentified; (fourth row) two unidentified, Kitty Beeler, two unidentified, Shirley Snarr, and two unidentified; (fifth row) Gee Gee Fisher, Mary Ann Cooley, Polly Dellinger, Susan Kitchin, Mary Marshall Venable, and two unidentified. (Courtesy Laura Ellen Beeler Wade.)

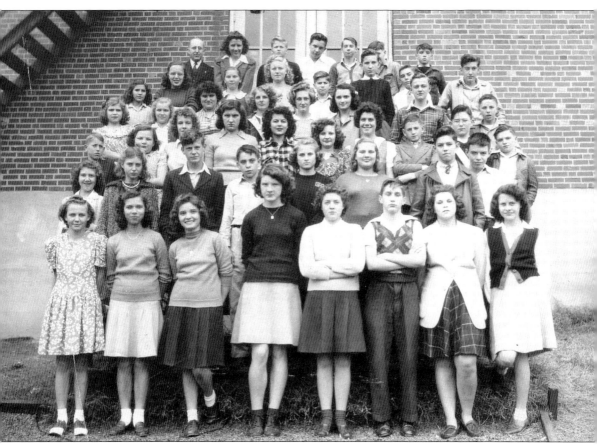

Only a few of the students in this group photograph can be identified. It is the graduating class of Strasburg High School in 1949. Graduates included Patsy Cameron Rutz, Leta Fry Bauserman, and Joanne Wolfe, who was able to identify some of the other students as Betty Keller, Virginia Bailes, Eleanor Vance, Randolf Via, Elizabeth Shacklett, Fay Ritenour, Christine Osborne, Lonnie Goad, Gloria Pringley, Bobby Senseney, Bill Holly, Donnie Grant, Helen Lichlighter, Peggy Nottinger, Bill Haley, Jack Boyer, Nancy Bly, Laura Campbell, and Donald Tamkin. (Courtesy of Kathy Combs Kehoe.)

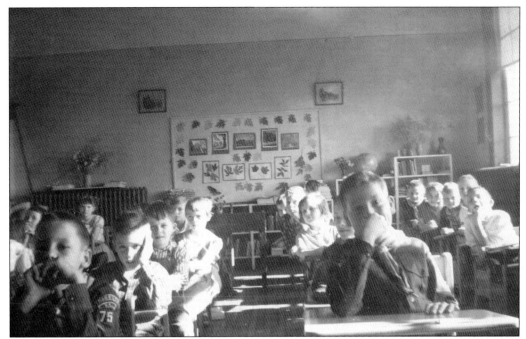

Teacher Virginia Cooper's fourth-grade class in 1958 at Strasburg Elementary would become the Strasburg High School graduating class of 1967. One of the children is identified as Charlie Himelright (up front wearing his Boy Scout Troop patch), and at various desks around the classroom are Donnie Griffey, Cindy Wolfe, and Bonnie Brown. (Courtesy of Laura Ellen Beeler Wade.)

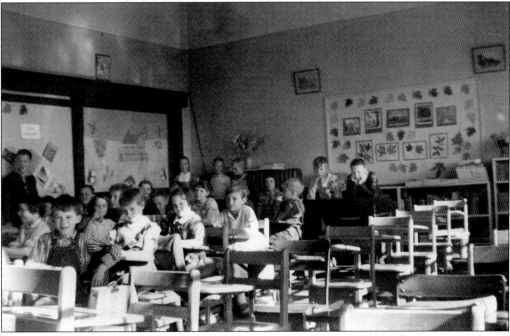

Some of the students identified in Virginia Cooper's 1958 class at Strasburg Elementary are Rocky Rinker (wearing his Scout uniform and standing against the bulletin board), John Ross Davidson, Ginny Bickle, and Gene Orndorff. (Courtesy of Laura Ellen Beeler Wade.)

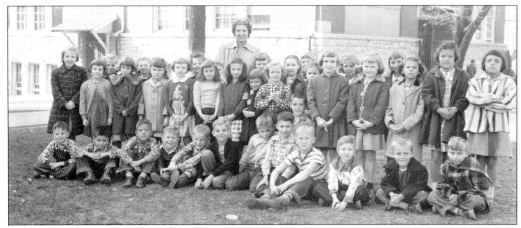

Virginia H. Beeler's second-grade class poses for a group picture with the old Strasburg Elementary School in the background. From left to right are (first row) unidentified, Larry Himelright, Larry Crabill, Charles Elbon, Casey Crabill, Larry Bright, unidentified, William "Bill" Funkhouser (plaid shirt), unidentified (behind Bill Funkhouser), unidentified (in striped shirt), Tommy Putnam, Dennis Fleet, and Tommy Grim; (second row) unidentified, Carol Devers, unidentified, Donna Munch, unidentified, Marie Spence, Carolyn Cootes, Darlene Cullers, Judy Jenkins, Lucille Miller (standing in front of Virginia Beeler), Susan Vann, Shelia Lemley (standing beside Beeler), Shelia Battle, Susie Ryman, Carol Ann Williams, unidentified, Vickie Maphis, Ruth Ann Davision, Kay Kibler, Mary Crawford, Gertrude Dellinger, Donna Ramey, and Vivian Vance. (Courtesy of Laura Ellen Beeler Wade.)

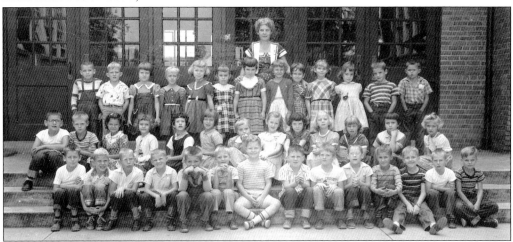

This photograph of Virginia H. Beeler's second-grade class was taken on the steps in front of the old Strasburg Elementary School's gym in 1955. The students are, from left to right, (first row) Gary Plaugher, Conley Crabill, Buddy Omdorff, Simmy Fisher, Jimmy Grant, unidentified, Tommy Downey, Paige Manuel, Winston Ritenour, Gary Neal, unidentified, John Horan, John Orndorff, and Jimmy Campbell; (second row) Dickie Golladay, unidentified, Elizabeth Himelright, Laura Ellen Beeler (teacher's daughter and visitor), Laura King (her father, Wayne King, was principal of the school at the time), Patsy Bly, Dorothy Ashby, Lana Sherman, unidentified, Wym Keeler, Elizabeth Bauserman, Diana Layman, and Henrietta Hockman; (third row) Ronnie Conner, Gary Riggleman, Debbie Alexander, Patricia Beeler, Brenda Sisk, Brenda Heflin, unidentified, Donna Henry, Dorma Bromley, Kitty Jenkins, unidentified, Tony Manuel, and Clark Richard. (Courtesy of Laura Ellen Beeler Wade.)

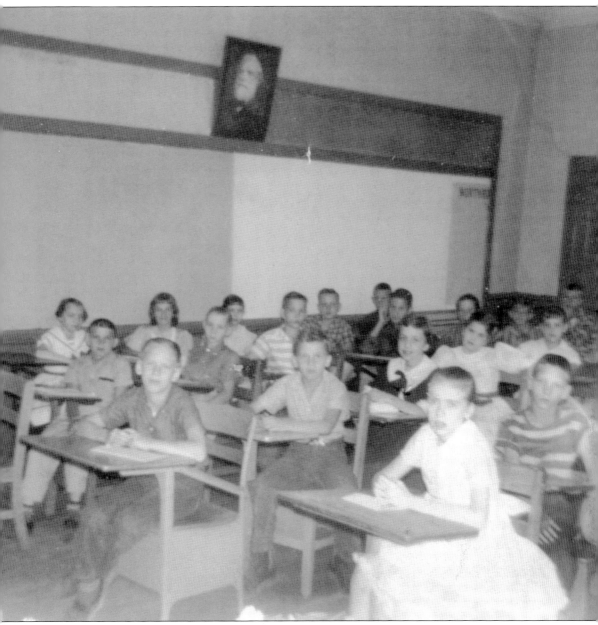

Fourth graders at Strasburg Elementary School are shown in their classroom in 1959. This class would graduate from Strasburg High School in 1967. Gen. Robert E. Lee's framed portrait hangs in the classroom. (Courtesy of Tom Peters.)

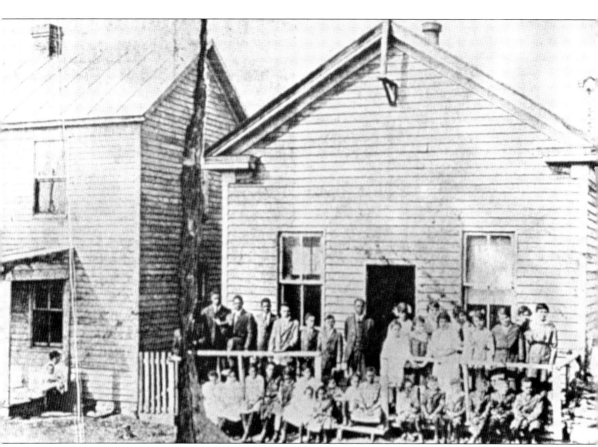

Students at the first segregated school in Strasburg for African Americans gather in front of the Queen Street School for a group picture. The school burned in 1929. Classes were held at the segregated men's Elks Club until Sunset Hill School was ready for classes. Students pictured are, from left to right, (seated) unidentified, Anna Mitchell, Odessa Lee, P. Butler, Winifred Byrd, Sarah Lee, Alease Witherall, Greta Hall, Harold Thompson, Iola Smith, Isabelle Hall, Joe Willis, Frank Willis, Otis Mitchell, Charles Thompson, Ashby Ralls, and Leroy Dyer; (standing) unidentified (obscured), Robert Chancelor, Jessie Boyd, Charlie Lee, Henry Lee, Lucian Butler, Elmer Mitchell, Melvin Ralls, teacher George Witherall, Marie Mitchell, Susan Lee, Gladys Gladwell, unidentified, Edna Willis, four unidentified, and Mabel Spinnard. On the porch at left are Nellie Nickens, Rebecca Hall, and Harold Thompson (at the screen door). (Courtesy of Strasburg Museum, Doug Cooley Collection.)

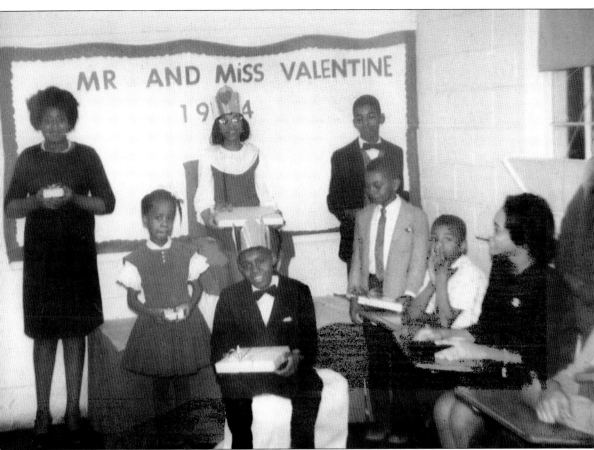

Mr. and Miss Valentine for 1964 at Sunset Hill School are Kathy Alsberry and Phillip Thompson, both with crowns on their heads. Shown with them are, from left to right, Edith Robinson, Stephanie Witherall, Edgar Ausberry, Wardell Strother, David Robinson, and Priscilla Alsberry. The class voted which classmates would be crowned Mr. and Miss Valentine in celebration of Valentine's Day. (Courtesy of Queen Street Sunset Hill School Alumni.)

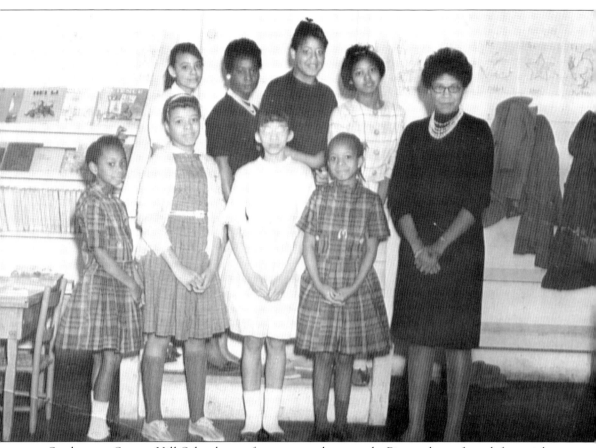

Students at Sunset Hill School pose for a group photograph. Pictured are, from left to right, (first row) Vanessa Witherall, Brenda Ausberry, Kathy Alsberry, Marquetta Witherall, and a Ms. Truesdale (teacher); (second row) Wanda Jackson, Rosa Brimmage (teacher), Edith Robinson, and Rebecca Alsberry. (Courtesy of Queen Street Sunset Hill School Alumni.)

Sunset Hill School teacher Selma Nickens Hill poses outside the school for a photograph. African American teachers usually lived in other communities and would board with students' families during the school week, traveling home on weekends and vacations. (Courtesy of Queen Street Sunset Hill School Alumni.)

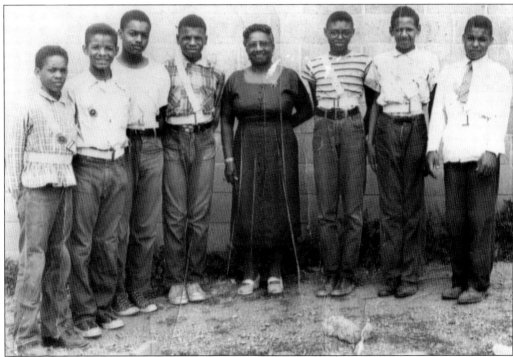

All seven students posing with their teacher Adora Payne are wearing safety patrol belts. The Student Safety Patrol helped supervise younger children, assist teachers, or alert teachers of any problems. Pictured are, from left to right, Johnny Alsberry, Paul Williams, Pete Pendleton, Robert Newman, teacher Adora Payne, Harold Thompson Jr., Charles Jackson, and Joe Strother. (Courtesy of Queen Street Sunset Hill School Alumni.)

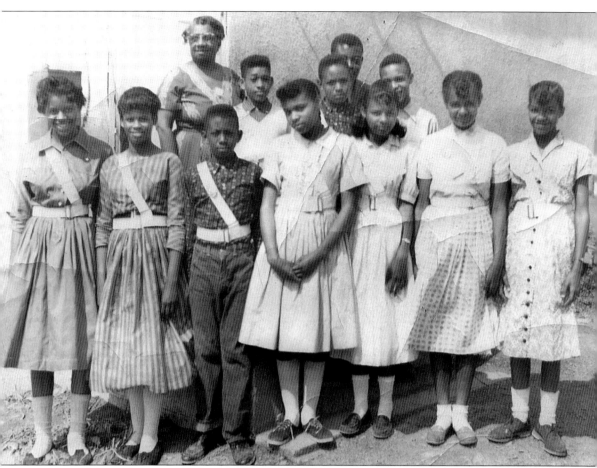

Most of the students in this photograph are wearing safety patrol belts. The Student Safety Patrol was a club promoting leadership and teaching students the importance of safety in the classroom and on the playground. The students had training before they could earn their white patrol belts. Pictured are, from left to right, (first row) Constance Jackson, Hilda Robinson, Carl Strother, Barbara Thompson, Virginia Payton, Josephine Pendleton, and Bernice Williams; (second row) Adora Payne (teacher), Leonard Alsberry, Billy Strother, George Heller (teacher), and Richard Strother. (Courtesy of Queen Street Sunset Hill School Alumni.)

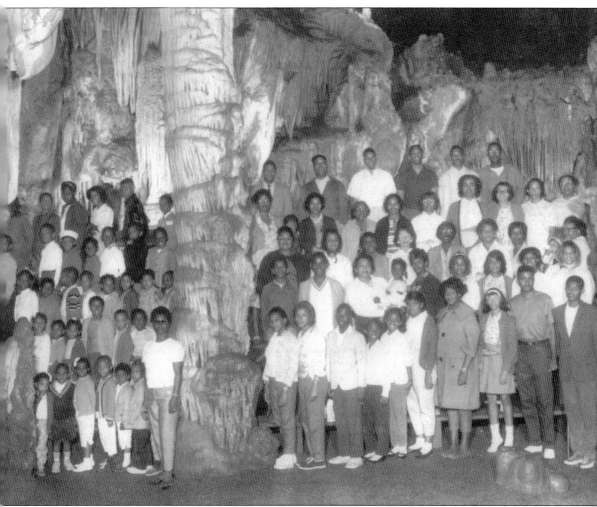

Sunset Hill School students took a field trip to Luray Caverns in 1963. The Luray Caverns is a large cave that is a registered natural landmark with the National Park Service and Department of Interior. It is a tourist attraction in the Shenandoah Valley and a popular field trip for area schools. Paying customers can walk on underground paths through the lighted cavern to view the natural geology of limestone stalactite and stalagmite formations. This group photograph shows the students and their chaperones inside the caverns. (Courtesy of Queen Street Sunset Hill School Alumni.)

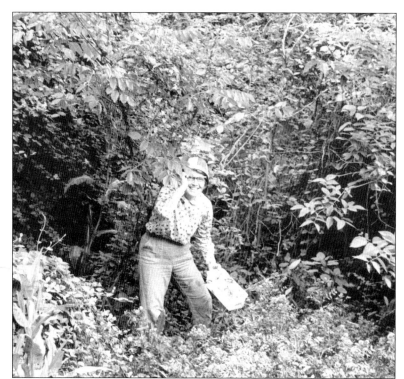

Teacher Sarah Falconer taught biology at Strasburg High School in the 1960s and 1970s. She is pictured here in her element, exploring biology in nature. (Courtesy of John P. Painter.)

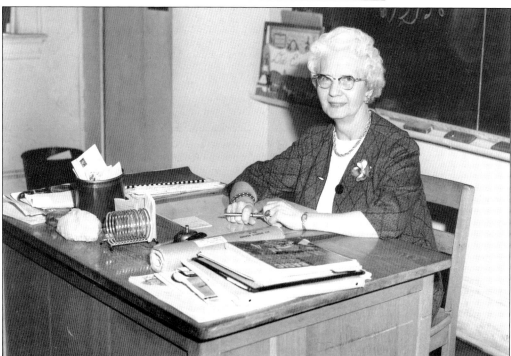

Teacher Virginia Cooper taught fourth grade for several generations at Strasburg Elementary School. She began her teaching career as a young woman and retired in the 1970s. (Courtesy of Laura Ellen Beeler Wade.)

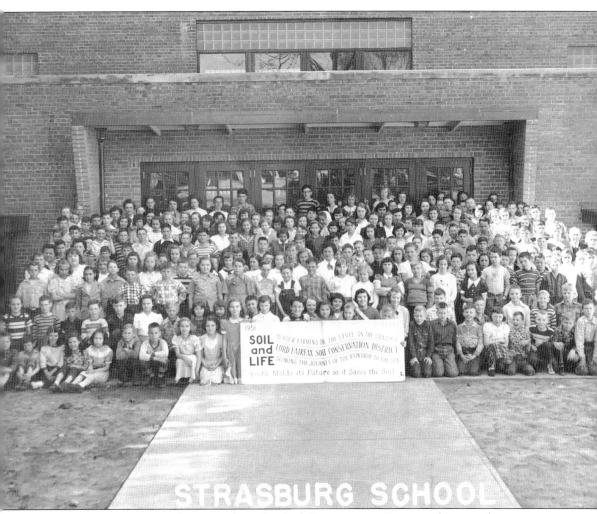

Students who participated in a Lord Fairfax Soil Conservation District educational activity in 1951 pose in front of the gym doors at Strasburg School. The group holds a sign with the slogan "Youth molds its future as it saves the soil." Students learned about soil conservation and pollution and participated in planting trees on school or public property. (Courtesy of George Hoffman.)

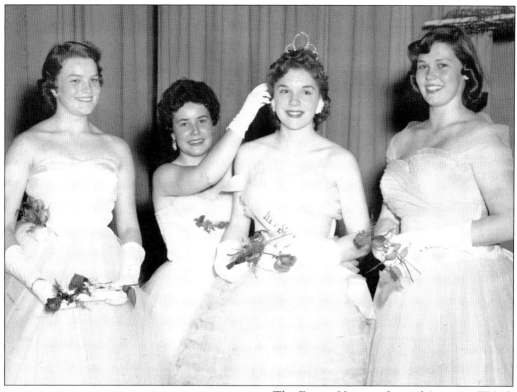

The Future Homemakers of America (FHA) club at Strasburg High School held a beauty pageant in 1957–1958. Contestants are Patricia Keller (left), winner Becky Steele being crowned, and Sally Hupp (right). The girl holding the crown is unidentified. The FHA was a girls-only club. The FHA class at the high school taught cooking and sewing. The Future Farmers of America (FFA) was a club for boys to learn about farming and soil and livestock management. In later years, the FHA and FFA were no longer separated by gender. (Courtesy of Park Hottel.)

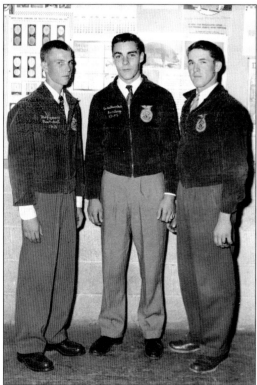

The Future Farmers of America was a popular school club promoting leadership, public speaking, and Robert's Rules of Order. Pictured are, from left to right, James Lindamood (wearing vice president Floyd Ryman's FFA jacket), secretary Lee Bullwinkle, and Allen Strosnider. The jackets were embroidered with the years "53–54" under members' names. The jacket also sported a FFA vocational agricultural badge. (Courtesy of Park Hottel.)

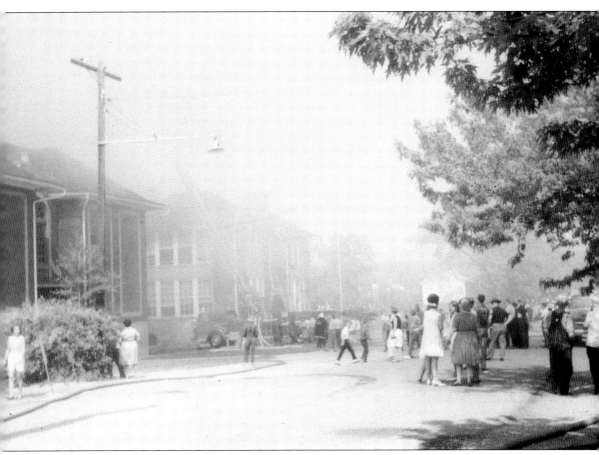

June 7, the last day of school in 1968, was when the oldest part of Strasburg Elementary School, built in 1910, caught fire and was destroyed. Note the girl with the white bow in her hair wearing a white dress (near center) for the seventh-grade graduation ceremony that was cancelled until the following Monday. At left, a mother is holding the hand of a small boy as they leave the street. As the firemen fight the blaze, townspeople, some students, parents, and town policemen gather on High Street while a haze of smoke surrounds the old building. (Courtesy of Glenna Loving.)

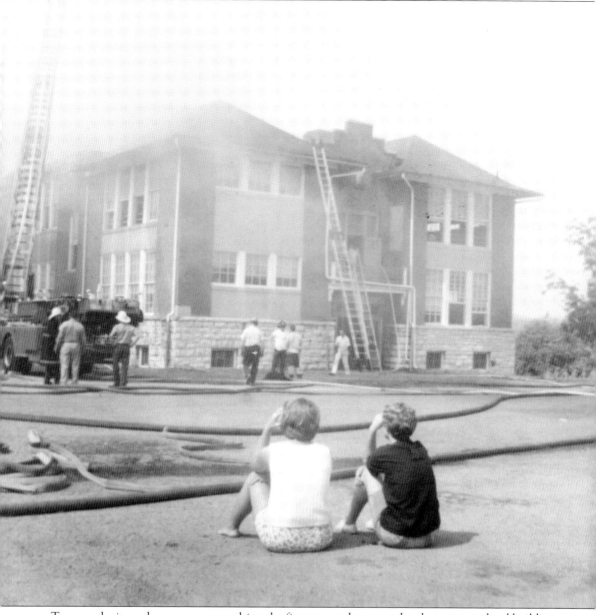

Two people sit on the pavement watching the firemen work to save the elementary school building. The fire alarm was pulled by second-grade teacher Virginia Beeler, and fourth-grade teacher Virginia Cooper called the fire department at approximately 8:00 a.m., according to the *Northern Virginia Daily* newspaper article the next day, Saturday, June 8, 1968. (Courtesy of Sheryl Pangle Pifer.)

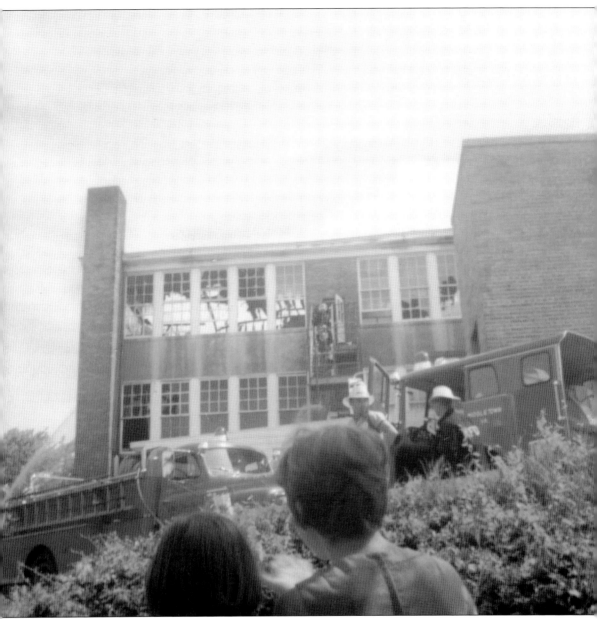

Firefighters battle the blaze at the elementary school on June 7, 1968, as two people watch from the back of the building. The next day, the *Northern Virginia Daily* newspaper article stated: "Firemen from Strasburg, Front Royal, Toms Brook, Middletown, Woodstock and Edinburg pumped thousands of gallons of water on the burning structure." (Courtesy of Sheryl Pangle Pifer.)

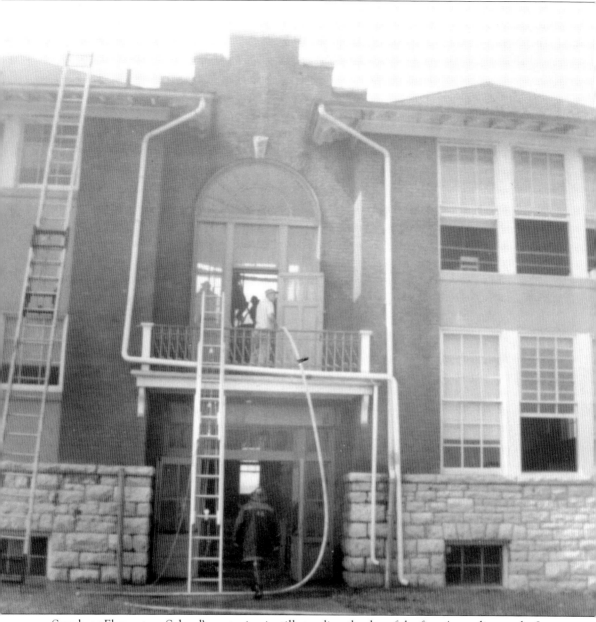
Strasburg Elementary School's west wing is still standing the day of the fire. According to the June 8 article in the *Northern Virginia Daily*, the fire companies "battled the blaze for approximately four hours before it was brought under control . . . crews kept the blaze contained to the old section of the U-shaped structure on Strasburg's High Street." (Courtesy of Sheryl Pangle Pifer.)

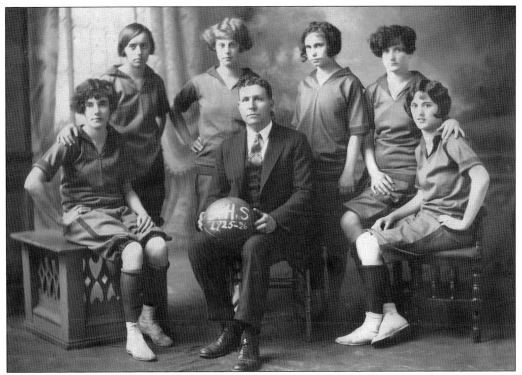

The Strasburg High School girls' basketball team poses for this photograph. Their coach and principal, G.W. Garner, is at center holding a basketball with the words "S.H.S. 1925–26." (Courtesy of Strasburg Museum, Doug Cooley Collection.)

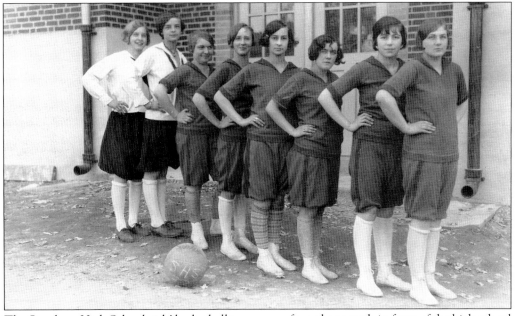

The Strasburg High School girls' basketball team poses for a photograph in front of the high school on High Street in the 1920s. The team members are unidentified except for Turah Stickley, who is fifth from the left. (Courtesy of Laura Ellen Beeler Wade.)

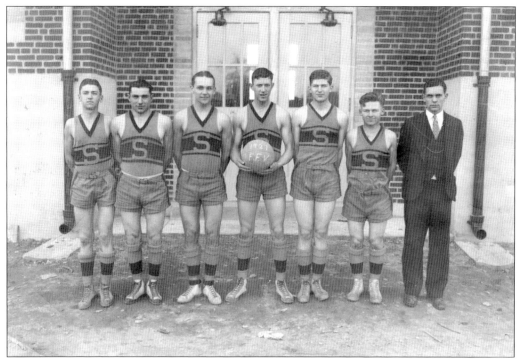

These six boys stand in front of what was then Strasburg High School. Sporting an S on their uniforms, they form the Strasburg High School basketball team for the school year 1927–1928. (Courtesy of Strasburg Museum, Doug Cooley Collection.)

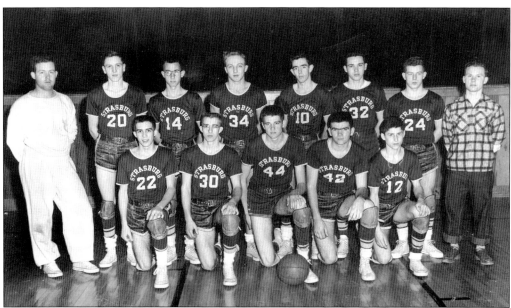

The Strasburg High School basketball team poses for a group photograph around 1955. All are unidentified. Their 1950s uniforms included leather belts, knee socks, and knee pads. (Courtesy of Park Hottel.)

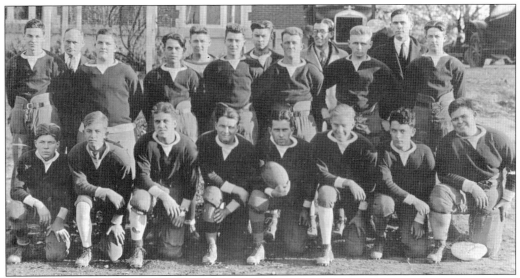

Strasburg High School's first football team was formed in 1929. Pictured are, from left to right, (first row) William Richard, James Ellis, Aubrey Johnson Jr., Jake Boyer, Arthur Artz, Bill Cooley, Joe Mitchell, and Allen Wolfe Jr.; (second row) Lewis Machir Jr., Charles Pollard, Curtis Bly, Sim Fisher, W. Davison, and Fred Kline; (third row) Edgar Ambrose, coach William Clem, Mark Strosnider, Burrell Beeler, manager John Finch, and coach Frank Wall. (Courtesy of Strasburg Museum, Doug Cooley Collection.)

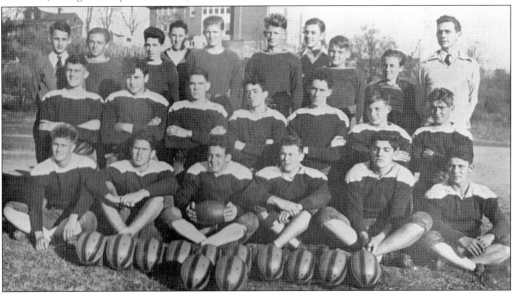

Strasburg High School's football team in 1936 poses for a group picture at Kline Stadium; the back of schoolhouse can be seen on the hill above. The Crimson Crusaders pictured here are, from left to right, (first row) Doug Cooley, Page Crabill, Charles "Buck" Kline, Joe Rosenberger, John Fred Larrick, and Curtis Vann; (second row) Ellis "Snow" Newell, Charles Hockman, Joe Bly, Julius Kaplan, John "Punk" Horan, Wayno Vann, and Jake Hammond; (third row) Floyd "Junior" Bowman, Beverly Bly, Albert Kaplan, Galen Poland, Cornwell "Red" Poland, Gene Wake, Bernard "Ty" Waterman, and coach Frank "Skipper" Wall; (fourth row) Dick Ambros and John Wake. (Courtesy of Strasburg Museum, Doug Cooley Collection.)

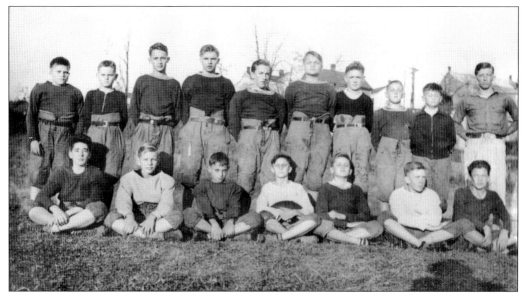

Harold Barr, pictured here fourth from the left on the first row, saved his Strasburg school football team group picture. It was taken in the 1940s. Barr grew up to become the pharmacist at Peoples Drug Store. (Courtesy of Betty Barr Colson.)

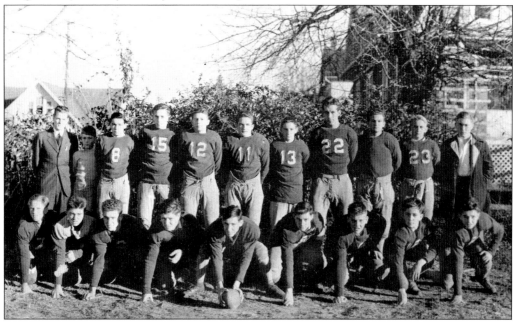

The 1941 Crimson Crusaders was the last football team from Strasburg High School to play before the beginning of World War II, when most of them were called for duty in the armed services. The team includes Jimmy Kronk, Bobby Ellis, Harold Updyke, Bobby Wolfe, Francis Steadman, Harry Keller, Donnie Horan, Leo Miller, coach Charles Cooley, Rodney Racey, Gene Smith, Bob Midkiff, Bill Midkiff, Courtney Carbough, John Rosenberger, Dick Horan, Charles Stinson, Delmar Osborne, and Ray Sonner. Two are unidentified. Others on the team who are not in the picture were Bobby Ritenour, Truman Rickard, Doug Mowery, and Clark Crabill. (Courtesy of Strasburg Museum, Doug Cooley Collection.)

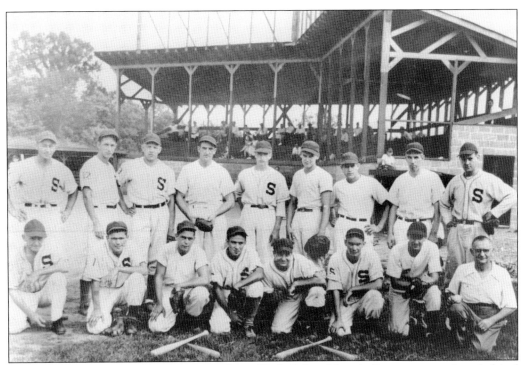

This undated photograph of the Strasburg High School baseball team was taken behind the schoolhouse on High Street at Kline Stadium. (Courtesy of Strasburg Museum, Doug Cooley Collection.)

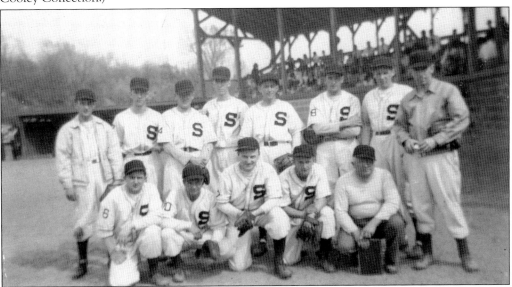

Kline Stadium, located behind the Strasburg High School on High Street, was named after Freddy Kline, the first soldier from Strasburg killed in World War II. The Strasburg baseball team is pictured in front of the stadium. From left to right are (seated) Joe Jenkins, Barney Boyer, Harry Emmart, J. Osborne, and Howard "Dusty" Rhodes (manager); (standing) Bud Barr, Gus Horan, Sim Fisher, Dick Horan, Frank Pangle, Charlie Yates, unidentified, and Earl Williams. (Courtesy of Betty Barr Colson.)

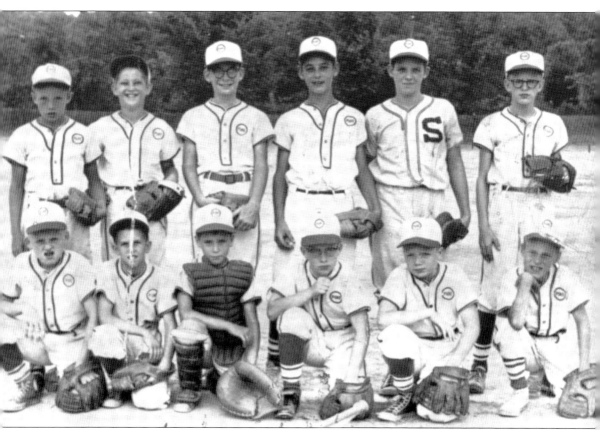

These Strasburg boys were part of the Pure Oil Peppers little league team coached by Barney and Jack Boyer. The team members identified by their classmates in this photograph taken in the summer of 1959 are, from left to right, (first row) Charlie Stover, Joe Hart, Jim Allamong, Forrest Morrison, David Jester, and Charlie Himelright; (second row) Jimmy Grant, Ray Lineburg, Jerry Racey, Ikie Himelright, Jerry Reynolds, and Terry Clem. (Courtesy of James Allamong.)

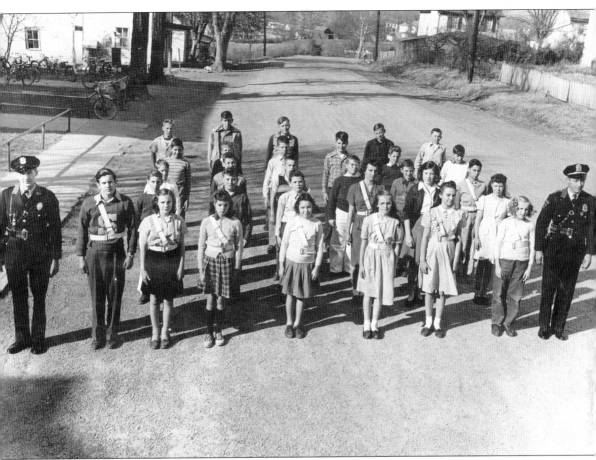

In the late 1940s, students at Strasburg School who were on the School Safety Patrol stand on High Street in front of the school with town policemen. The student safety patrol helped supervise younger children on the playground, assisted teachers and bus drivers, and responded to students who needed help. Flanking the students are officer Paul Neal (left) and officer Frank Pangle (right). Strasburg policemen helped educate the students in safety. According to an article in the *Northern Virginia Daily* on June 8, 1968, when the west wing of the elementary school caught fire in 1968, the "children were immediately evacuated by the safety patrol. The student unit, under the direction of Henry Utz, drew much praise from the public for its swift action." (Courtesy of Strasburg Police Department.)

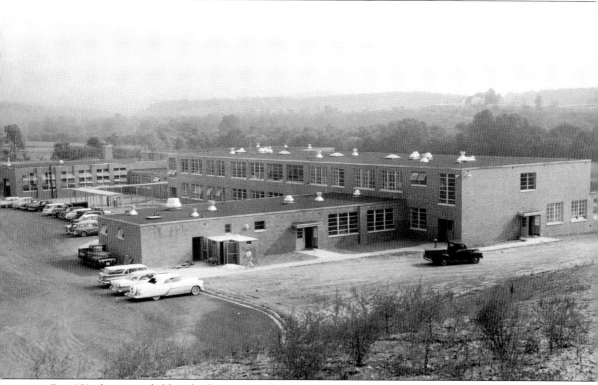

By 1959, the town children had outgrown the school on High Street, and so a new high school was built for grades 8 through 12. Several additions have been built over the years to accommodate a growing population. (Courtesy of Park Hottel.)

*Four*

# THE NEIGHBORHOOD

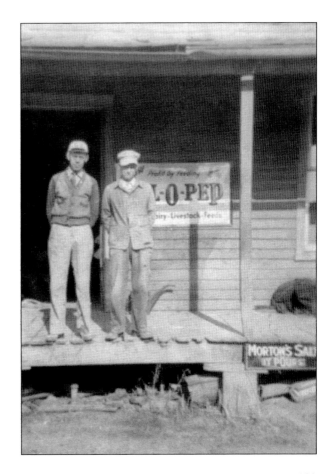

Mose Snarr (left) and Virgil Hoffman stand on the porch of the Snarr Feed Store in the late 1920s or early 1930s. Behind them is a sign advertising a brand of animal feed: Ful-O-Pep. (Courtesy of George Hoffman.)

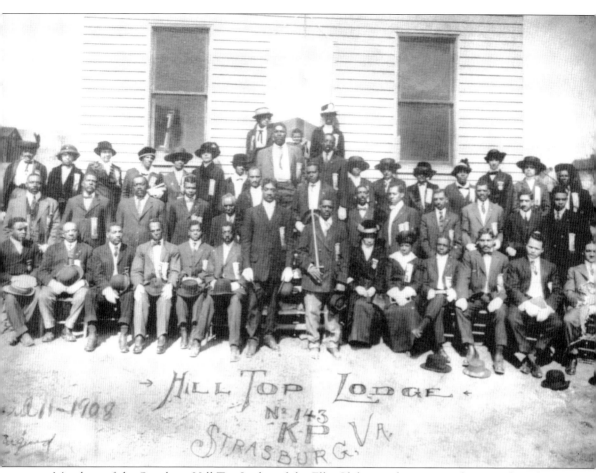

Members of the Strasburg Hill Top Lodge of the Elks Club pose for a group photograph in front of their headquarters on April 11, 1908. The Elks Club was a nonprofit charitable fraternal organization with discriminatory requirements for membership until its bylaws were changed in 1972. Because they were denied membership in the all-white Elks Clubs, African Americans in many communities formed their own clubs. (Courtesy of Strasburg Museum, Doug Cooley Collection.)

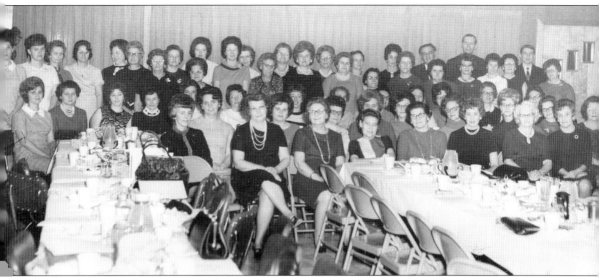

New York–based Aileen Incorporated opened a sewing factory in Strasburg in 1955. The Aileen plant employed several hundred people who made women's double-knit clothing. It was known as a good place to work, with good benefits and the first air-conditioned factory in town. Strasburg Manufacturing bought and operated the factory until the 1980s. The company hosted a dinner at the Stone Shop Restaurant on January 29, 1969, to honor employees of the Aileen plant with more than 10 years of employment. Included in the picture are Bessie Baker, Martha Boyer, Nannie Alhizer, Iva Mae Orndorff, Mamie Hill, Madolyn Pangle, Beulah Weaver, Julia Putman, Mamie Stokes, Dorothy Burnett, Charlotte Hall, Daisy Glidewell, Gertrude Hoffman, Mamie Ashwood, Lina Bly, Betty Baker, Nan Lancaster, Nancy Cameron, Theresa Robinson, Betty Wilson, Genevive Fox, Anna Pittington, Moline Williams, Anna Lee Miller, Elizabeth Lam, Mary Hollar, Fleda Dyke, Louie Andrick, Ethel Bly, Mary Rutz, Betty Miller, Phyliss Kipps, Marguerite Walker, Thelma Sells, Georgia Shipe, Kathryn Fisher, Nina Keller, Grace Pangle, Cathryn Sibert, Jerry Stinson, Clara Rickard, Mildred Jenkins, Nina Crabill, Nina Pangle, Nancy Pingley, Viola Mumaw, Dorothy Williams, Ruth Heltzel, Ruth Holsinger, Mary Ramey, Frances Copeland, Rebecca Hockman, Ted Sambol, Ray Riley, Anna Showers, Mary Jenkins, Hazel Hensell, Randy Miller, and Grace Hall. (1969 Aileen newsletter; information courtesy of Teresa Snarr Hensley, image courtesy of Nancy Cameron.)

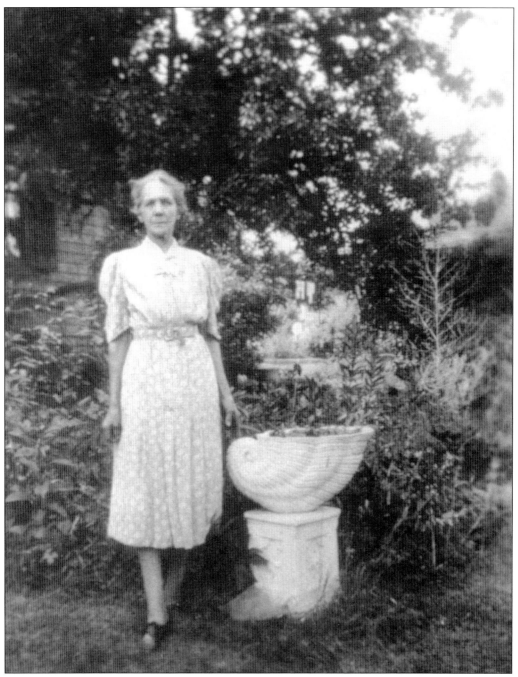

Grace Eberly poses for a photograph in her yard beside a pedestal made of pottery pieces from J. Eberly & Bros. Pottery. She was the widow of local potter Daniel Letcher Eberly. Proudly independent, she had boarders, raised chickens and sold eggs, grew flowers in her yard for sale, and lived in her own house on East Washington Street until she was 100 years old. Her neighbors and other town residents, each in their own way, helped her maintain her independence. The house is now owned by the Marx family, who have preserved and honored the history of Grace Eberly's home. (Courtesy Mike and Liz Marx.)

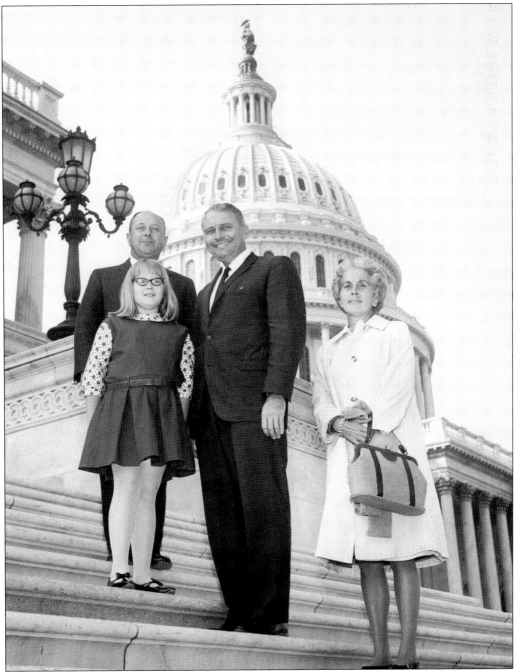

John O. "Jack" Marsh Jr. was a well-known member of the Strasburg community. He was a US congressman representing Virginia from 1963 to 1971. He was former secretary of the Army, had a law practice in Strasburg, served as town magistrate, and was active in the Jaycees service organization. He is pictured here at center on the Capitol steps in 1967 with Clayton and Ann Sager and their daughter Ginger Sager Glading. (Courtesy of Ginger Sager Glading.)

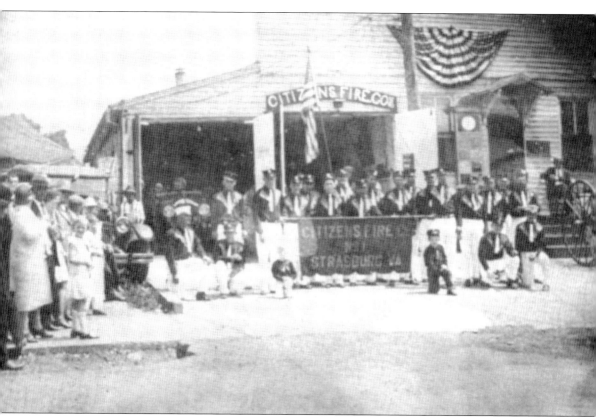

In full uniform, the Strasburg Volunteer Fire Department poses for a group picture with the fire trucks and banner ready for the 1932 Firemen's Parade. Behind them, a sign advertises the annual Firemen's Carnival. They are gathered in front of the original town hall; the fire station was on the left side of the building and the police department on the right. This building was replaced in 1951 by the brick fire station seen today. (Courtesy of Strasburg Museum, Doug Cooley Collection.)

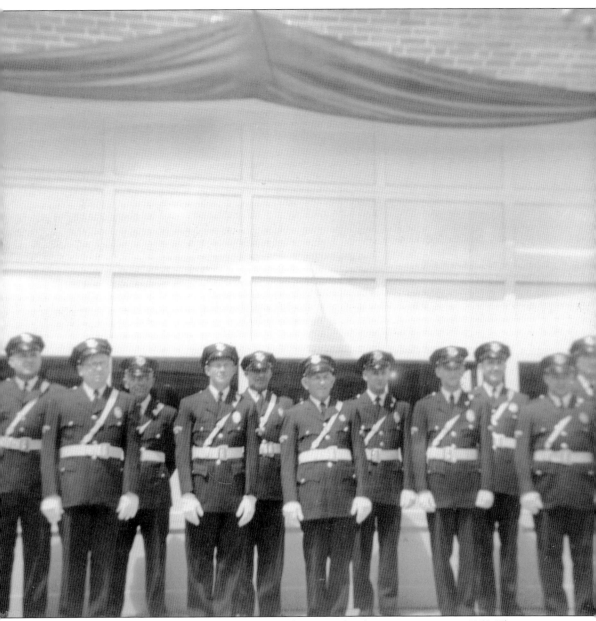

The Strasburg Volunteer Fire Department members pose for this group picture in 1955. The names of the firemen are not recorded, but three of the volunteers are identified as Raymond Beeler, George Trimble Sr., and Tilden Ashwood. (Courtesy of Strasburg Museum, Doug Cooley Collection.)

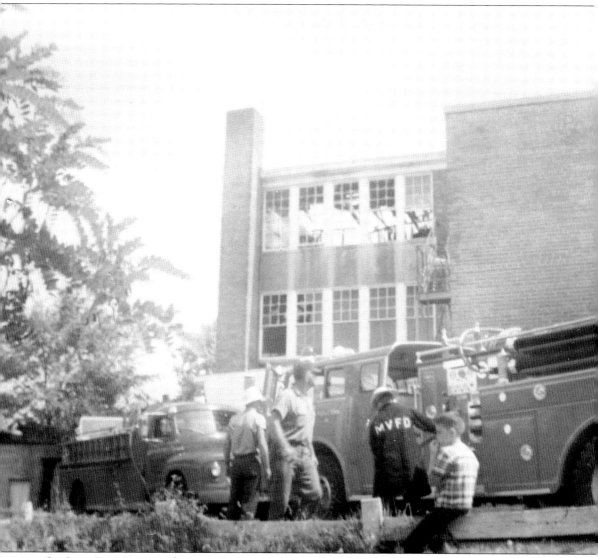

On June 7, 1968, as students were arriving for the last day of school, the Strasburg Volunteer Fire Department was called out to a fire at Strasburg Elementary School. A Middletown Fire Department fireman is also seen in this photograph. The right side of the school, housing grades one through four, was destroyed by fire that day, but because the fire broke out before classes started, there were no injuries. The *Northern Virginia Daily* reported the next day that "efficient work by the fire-fighting crews kept the old section of the U-shaped structure on Strasburg's High Street." (Courtesy of Sheryl Pangle Pifer.)

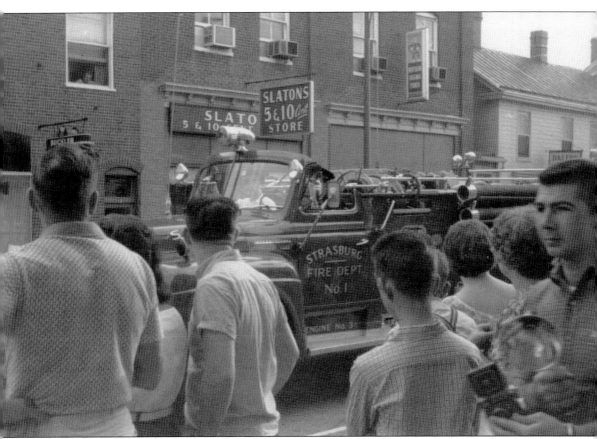

Here, Strasburg Fire Department members drive one of its trucks in the annual Firemen's Parade. Bill Orndorff, an employee of the *Northern Virginia Daily*, stands on the sidewalk on King Street with his camera. A spectator can be seen in one of the apartment windows watching the parade. The store signs—Slatons 5 & 10 Cent Store, the Northern Virginia Power Company, and Dalton alteration shop—indicate the photograph was taken in the 1960s. (Courtesy of Betty Barr Colson.)

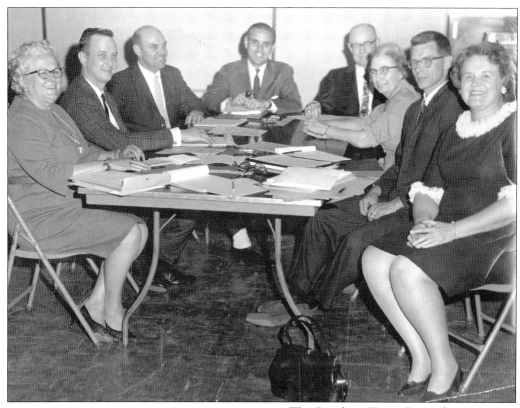

The Strasburg Town Council Recreation Committee brought many activities to the town. Marie Williams, pictured here on the far left during a Recreation Committee meeting, was one of the original advisors for the Strasburg Teenage Club, formed in 1958, chaperoning dances for several generations until the 1970s. (Courtesy of Martha Williams Brill.)

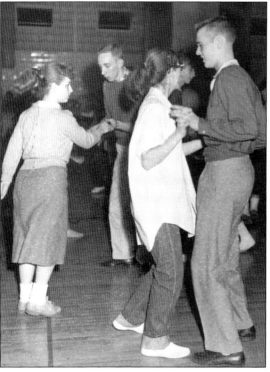

Although this picture was taken in the Strasburg school gym on High Street in the 1950s, it is reminiscent of the teen dances held at the Fire Hall in the upper social hall. One of the dancers is identified as Alfred Racey. Marie Williams used a record player to play popular songs and sometimes hired local teenage bands to play live music. (Courtesy of Park Hottel.)

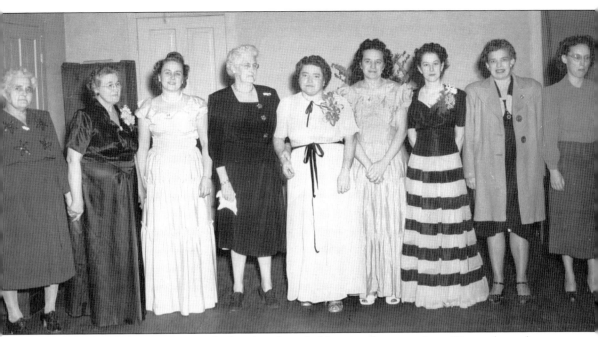

The Strasburg Fire Department Ladies Auxiliary held regional conventions. Pictured are, from left to right, Lula Strosnider, Anna Racey, Ruth Beeler, Effie Kline, Hilda Rudolph, Mabel Miller, Margaret Bromley, unidentified, and Alta Miller. The women in this organization supported the fire department in many ways, including fundraising for the department. (Courtesy of George Hoffman.)

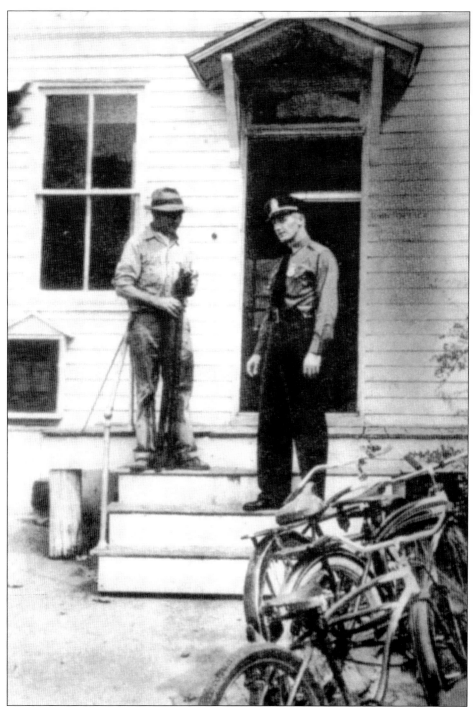

Town manager Tim Guthrie and chief of police Paul Neal stand in front of the original Strasburg Town Hall, which was demolished in 1951 so that a new building could be constructed for the town office and for the police and fire departments. The building is now used as the fire station, while a new town hall was built across the street in 1991. (Courtesy of Strasburg Museum, Doug Cooley Collection.)

Robert Keller was the chief of police in Strasburg from 1921 to 1936. (Courtesy of Strasburg Police Department.)

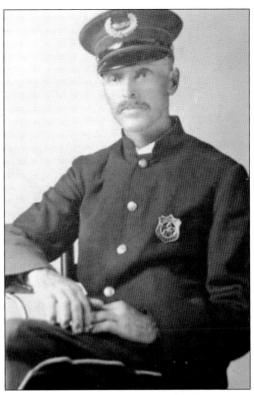

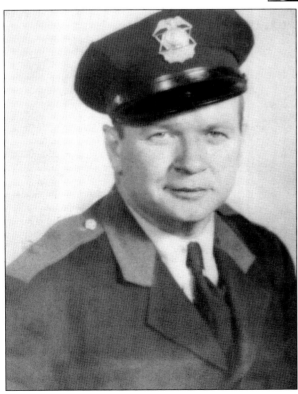

Charles Crabill was the chief of police in Strasburg from 1936 to 1946. (Courtesy of Strasburg Police Department.)

Frank Pangle was the chief of police in Strasburg from 1946 to 1947. (Courtesy of Strasburg Police Department.)

Harry Frances Emmart, a Strasburg police officer in the 1940s, is pictured here in his brother's drugstore. Officer Emmart was first on the scene when the pharmacist at Peoples Drug Store was murdered in 1947. (Courtesy of Strasburg Police Department.)

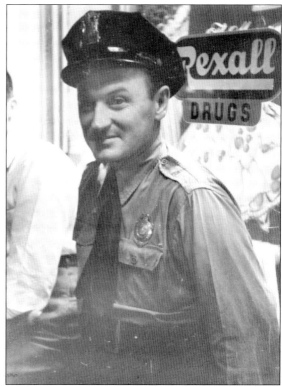

Paul J. Neal Sr. was the chief of police in Strasburg from 1947 to 1971. He, like many other Strasburg men, served in World War II. He landed on Omaha Beach on June 6, 1944. (Courtesy of Strasburg Police Department.)

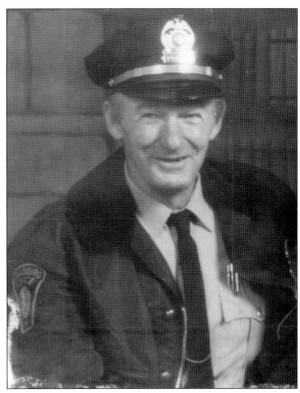

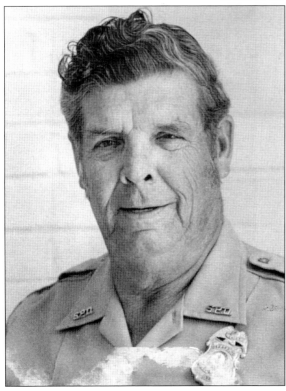

Roger J. Ramey was the chief of police in Strasburg from 1971 to 1981. (Courtesy of Strasburg Police Department.)

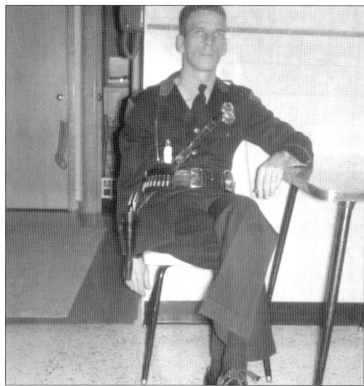

William David "Bill" Lucas was a Strasburg town policeman in the 1960s, pictured here seated in the police station. (Courtesy of Debbie Lucas Seekford.)

Bill Lucas went on to serve as district director of the US Customs Patrol. He and his family remained Strasburg residents although he was stationed at Dulles Airport in Leesburg. (Courtesy of Debbie Lucas Seekford.)

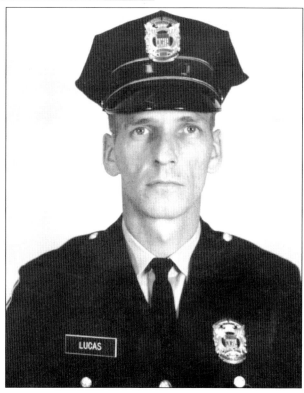

Two town policemen, Paul Neal (left) and Roger Ramey (right), pose for a photograph with Santa Claus. These two men lived and worked in the community and took time to have some fun over the holiday. (Courtesy of Strasburg Police Department.)

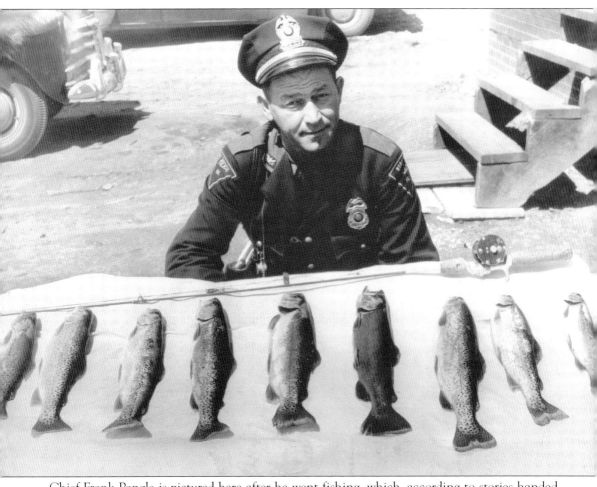
Chief Frank Pangle is pictured here after he went fishing, which, according to stories handed down through the police department, caused teasing and joking among his fellow officers and some townspeople with references to Mayberry. (Courtesy of Strasburg Police Department.)

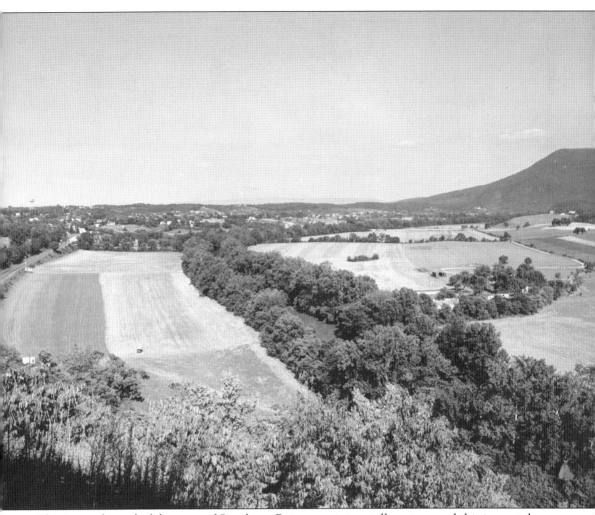

This is not the end of the story of Strasburg. But every picture tells a story, and this image takes the viewer back in time to the 1960s. The landmark of Signal Knob on Massanutten Mountain announces that the town of Strasburg is ahead. Several billboards can be seen along Route 11. Trees line both sides of the Shenandoah River, and the fields between the highway and the river are often searched by people walking them when freshly plowed looking for Indian arrowheads, evidence of the native culture long before the new settlers arrived in the wilderness of the Shenandoah Valley. (Courtesy of Park Hottel.)

# Discover Thousands of Local History Books Featuring Millions of Vintage Images

Arcadia Publishing, the leading local history publisher in the United States, is committed to making history accessible and meaningful through publishing books that celebrate and preserve the heritage of America's people and places.

Find more books like this at
**www.arcadiapublishing.com**

Search for your hometown history, your old stomping grounds, and even your favorite sports team.

Consistent with our mission to preserve history on a local level, this book was printed in South Carolina on American-made paper and manufactured entirely in the United States. Products carrying the accredited Forest Stewardship Council (FSC) label are printed on 100 percent FSC-certified paper.